LIGHTING AND PHOTOGRAPHING

TRANSPARENT AND TRANSLUCENT SURFACES

A comprehensive guide to
photographing glass,
water, and more

DR. GLENN RAND

AMHERST MEDIA, INC. ■ BUFFALO, NY

Published by:
Amherst Media®
P.O. Box 586
Buffalo, N.Y. 14226
Fax: 716-874-4508
www.AmherstMedia.com

Publisher: Craig Alesse
Senior Editor/Production Manager: Michelle Perkins
Assistant Editor: Barbara A. Lynch-Johnt

ISBN-13: 978-1-58428-244-0
Library of Congress Control Number: 2008926664
Printed in Korea.
10 9 8 7 6 5 4 3 2 1

CONTENTS

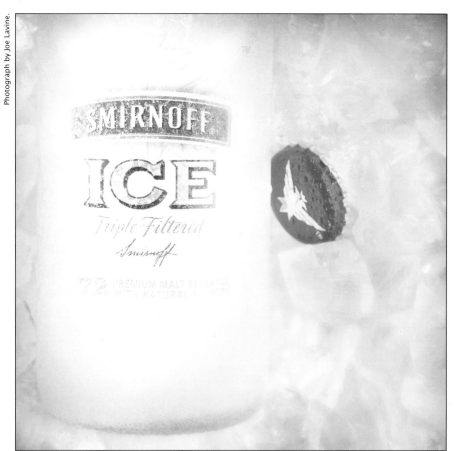

Photograph by Joe Lavine.

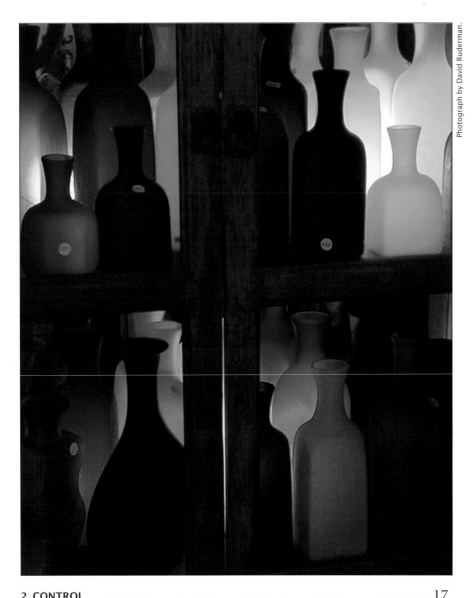

Photograph by David Ruderman.

Photograph by John W. Gutowski.

INTRODUCTION

This book is about making images of transparent and translucent materials. We normally think of this as lighting glass, but there are many other materials that act the same; these include plastic, water, and gels to name a few.

Creating images of transparent and translucent objects is a complex undertaking. As you read through these pages, you'll learn the basic concepts required to photograph these materials. We start with a philosophy for lighting glass, a look at the physics of light (this is embellished in the book's appendix), and an overview of the basic controls for photographing transparent and translucent materials. We then turn our attention to the application of

The setup used for this image included specific lighting for the sandblasted reindeer. Specular and diffused light created the white lines. The blue lines were created by dispersion of the specular light illuminating the rear of the sculpture, which reflected from the polished bottom surface. Photograph by Glenn Rand.

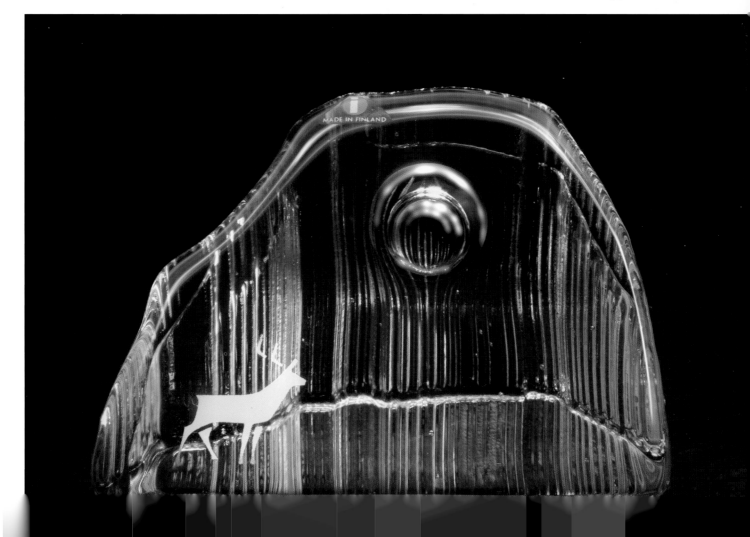

two major lighting techniques used to photograph transparent and translucent materials: black-line and white-line lighting patterns. With the basics of lighting addressed, we'll investigate the light metering and exposure control techniques used in making images of transparent and translucent materials. The last four chapters address specific studio applications, including using glass that does not become the subject or disappears, using Photoshop when creating images of transparent and translucent subjects, and photographing water. Finally, there is an appendix dealing with the basic optics involved in lighting glass and other transparent and translucent materials.

Though the intent of the book is to assist you in making better photographs of transparent and translucent subjects, it is not a "cookbook." It is my goal to assist you with your photography without suggesting that there is only one way to make these images. Therefore, this book presents discussions of how lighting works with transparent and translucent materials and includes many examples of how these principles are applied in various situations. The book explains the thought processes used to make the sample images and shows just how the various controls were applied. This will allow you to see how you can use these same controls to create your own images.

As you read through the book, take the time to carefully review the illustrations and captions, which detail specific techniques and strategies for producing excellent images. These captions and illustrations mirror the text to reinforce the material and speed your learning and mastery of the applications discussed.

IT IS MY GOAL TO ASSIST YOU WITH YOUR PHOTOGRAPHY WITHOUT SUGGESTING THAT THERE IS ONLY ONE WAY TO MAKE THESE IMAGES.

A PHILOSOPHY FOR LIGHTING GLASS

IT IS IMPORTANT TO

UNDERSTAND THAT THERE

ARE LIMITS TO THE WAYS IN

WHICH LIGHT CAN BE USED.

For many photographers, lighting and photographing glass (or, more correctly, transparent and translucent materials) is troublesome. Light interacts differently with these materials than it does with most other subjects; reflections may result, the color temperature of the light may be affected, and other unique factors may impact the overall look of the image. This is true whether the photographer is using film or digital capture to photograph the subject.

As we begin the journey toward understanding how light impacts our options for photographing these challenging subjects, it is important to understand that there are limits to the ways in which light can be used. Though this fact may seem constraining, there is a bright side: if there are few alternatives in solving lighting problems, we can quickly survey our options, address issues, and expend our mental energies more creatively.

SETTING THE LIMITS

There are many factors that go into photographing transparent and translucent objects, but none are more important than these materials' interaction with the light. (Those who wish to learn a bit more about how these interactions occur can turn to the appendix of this book for a brief description on how various optical phenomena affect transparent and translucent photography.) Though many photographers believe that lighting transparent and translucent materials is difficult and complex, with the right approach and knowledge of what the materials will allow, the task of creating good photography of transparent and translucent subjects is quite manageable.

_The first step in developing a strategy for the effective lighting of transparent and translucent subjects is understanding the limits of the materials. There are very specific concepts that control the way the light interacts with these subjects. When these interactions are held as constants, controlling the light loses some of its complexity.

_Though taking a scientific approach to the art of photography may seem to encourage the production of stilted, stiff images, there is more that goes into

To create this image, Douglas Dubler had clear ice carved to allow the model to come through. To provide color, a purple light was used on the side of the ice so that none of its color reached the front of the model. The light coming through the ice is created by fire. The front striplights and the model's hair created the flame-like patterns on the front of the ice emanating from the model's hand and next to her head. These reflections are similar in color to the model's head. Dubler is very precise with his lighting, color balancing, and exposure to ensure that the results are exactly as he planned.

creating a photograph than developing a lighting strategy. Though the lighting chosen for the photographic subject will give great emphasis, quality, and feel for a photograph, it is seldom the only or most important part of the image. Light and lighting are the environmental concerns that enable photography, not the photograph.

In order to build the best-possible photographs, we must understand how to make use of our lighting. The easiest way to do this is to conceptualize light as an environment that totally surrounds the subject. All the light used

This image shows the two major issues that photographers face in making pictures of glass. On the left is a map behind Plexiglas. A fluorescent light across the subway car strikes the subject and emphasizes the scratches and texture on the Plexiglas. The Plexiglas reflects the light in a manner that's similar to the reflections caused by the polished stainless steel next to it. The window glass on the right is clean with a dark field behind it. Therefore, the fluorescent bulb and reflector at the top and a light outside the subway car shows as the train speeds by. Photograph by Glenn Rand.

to illuminate the subject, as well as any ambient light that can affect the subject, creates this environment, called the light envelope. This envelope also includes lighting not considered part of the setup that might be seen in the subject or reflections in the scene. For example, a photographer wearing a white shirt might become a fill or reflection in the scene when illumination reaches their shirt.

SO WHAT'S THE PROBLEM?

Light interacts with all materials, and without that energy source, vision and photography would not be possible. With most photographic subjects, the interaction occurs on the surface, and it is relatively simple to use lighting to

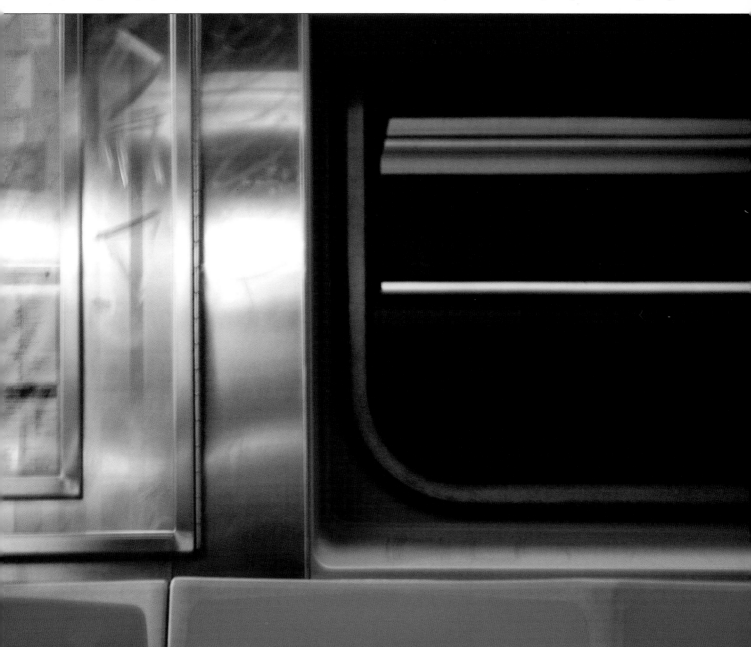

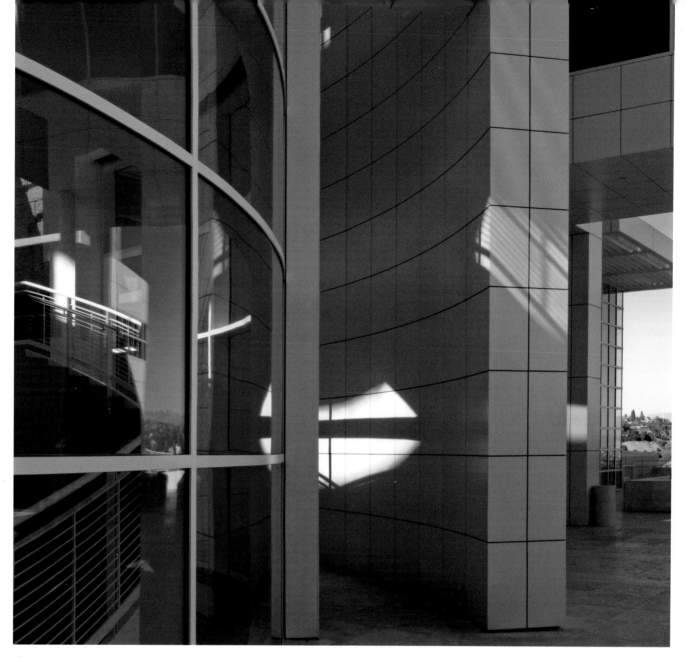

The curved windows distort the reflection of the scene while allowing light to penetrate, creating the light patterns on the curved wall. Because some of the reflections are of the shadow sides of other buildings, we are able to see through the glass and view the curved ramp behind the window. Photograph by Glenn Rand.

make the subjects look as the photographer wishes. Most transparent and translucent materials possess increased reflectivity that can be intense and further transmits light through the material. When light interacts with these subjects, its direction, intensity, concentration, and color may be modified, presenting unique challenges for the photographer.

The optical functions of transparent and translucent objects can change the characteristics of the exposure needed to acquire the desired photograph. Because achieving an accurate exposure will often entail using the camera in manual mode, having a working understanding of metering and exposure is essential to ensuring success during the photographic session. With both transparency film and digital capture, the highlights and bright areas are most

critical. The reflectivity and transmission of light when photographing glassy materials makes nonautomatic metering the best choice for ensuring proper exposure.

I'LL FIX IT LATER

Many individuals who are familiar with the potentials of digital imaging and image-editing software see it as a way to fix problems they encounter when photographing transparent and translucent subjects. However, as Ike Lea, a digital photography instructor, once said, "Bad lighting for digital photography is still bad lighting." The quality of the captured image greatly influences the quality of the final image. Unless you are a highly skilled technical illustrator, it is doubtful that you can use your software to generate the effects that will be required for a photo-realistic image. It is easier to light the subject correctly prior to capture.

The lighting for this photograph of a glass ball includes specular light for the detail forms and bubbles inside the ball and diffuse light around and to rear of the set to create the white-line accent on the contour of the ball. Photograph by Glenn Rand.

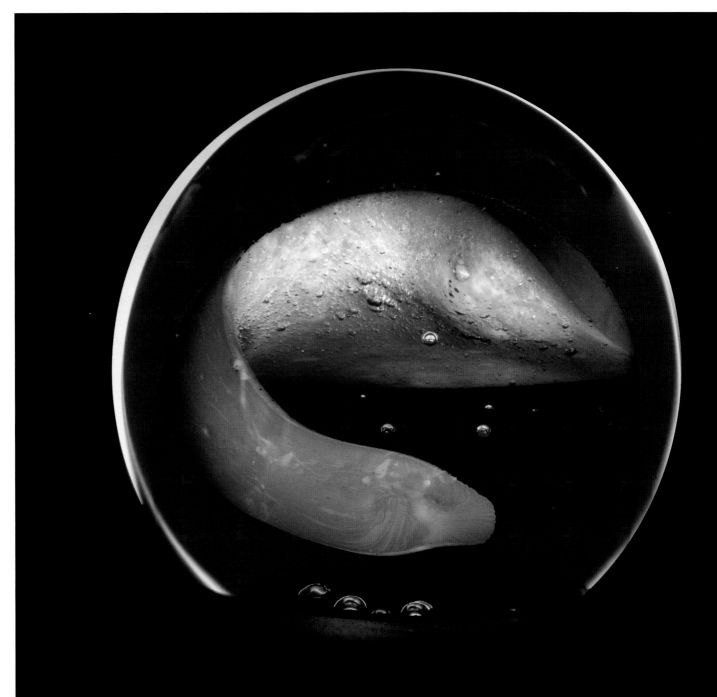

When photographing transparent and translucent subjects, it's possible that specular and incident light will create highlights with a tonality beyond the capability of the sensor to capture. Some photographers believe that capturing the image in the RAW format will allow for the correction of lighting problems post-capture. Though this digital capture method provides some opportunities to correct for small errors in lighting, it cannot correct gross overexposure.

THE LANGUAGE OF PHOTOGRAPHY

Photography is a beautiful language. It can make the glass look half full or half empty. Just as with any language, there are various structural parts of this visual language. In photography, the subject is the center of meaning and the focus of the communication, just as it is in our verbal constructions.

This image by J. Seeley was made on a scanner. A block of ice was cut out and polished to hold the skull. The ice acts as a transparent material where it is polished and is translucent where air was trapped in the ice. The transparent areas allow us to clearly see the plastic skull. Where the ice is not clear, the background is diffused. Light entered the scanner from a skylight that is shown both in the bright highlights on the front of the skull and refracted as an image from the base of the neck.

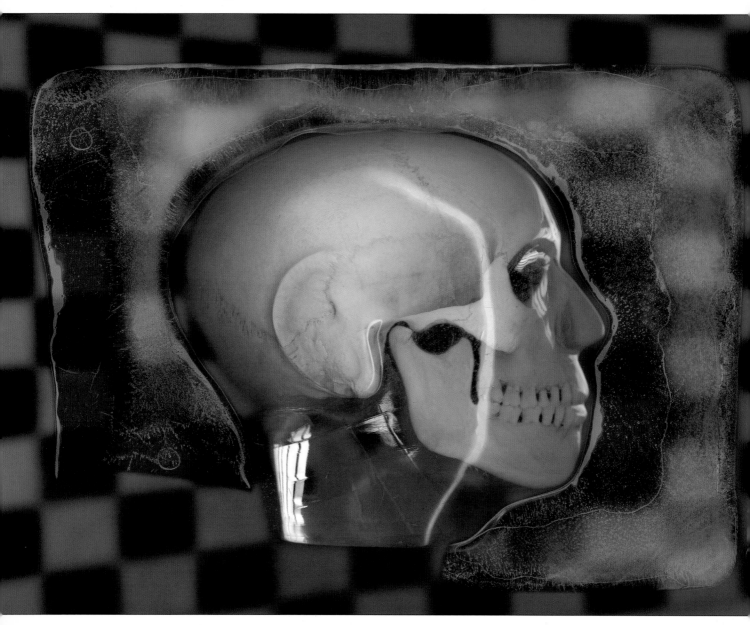

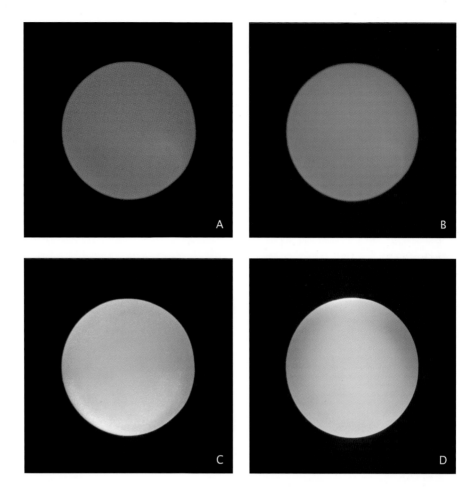

Light defines the subject and adds to its meaning much in the same way as adjectives add meaning in a sentence. With words and light we can say,

"There was a translucent ball." (A)
"There was a green translucent ball." (B)
"There was a green translucent ball that glowed from within." (C)
"There was a multi-toned green translucent ball that glowed from within with a highlight on top." (D)

All the images in the sequence above show the same ball, photographed from the same spot but lit differently. (Obviously, the first was produced in grayscale.) The way the light was used changed the way the image described the subject. That is the power of lighting as part of the language.

THE WAY THE LIGHT WAS USED CHANGED THE WAY THE IMAGE DESCRIBED THE SUBJECT.

Language, whether verbal or visual, is a powerful tool through which to communicate ideas. However, there is a caveat to be added to this brief discussion. At a lecture in Finland, the speaker asked how many languages were spoken by the attendees in the audience. Everyone but the presenter spoke more than two languages. The lecturer then asked, "How many languages do you need if you have nothing to say?"

Gorgeous lighting is unimportant if your photograph holds no message.

GLASS AS TRANSPARENT AND TRANSLUCENT

In this book, the term "glass" is used to generically refer to transparent and translucent materials. Glass has attributes shared by many transparent and translucent materials: it is usually highly reflective on one surface and transmits light. It may have a textured surface that renders it translucent. It may be colored and, if so, it will create filtered light—or it can totally reflect the light from its surface.

In this book we will deal with not only glass, but with other transparent or translucent materials, such as the balls used in the example on page 15. With the exception of some materials with unique qualities, like liquids, they will be handled as if they are glass.

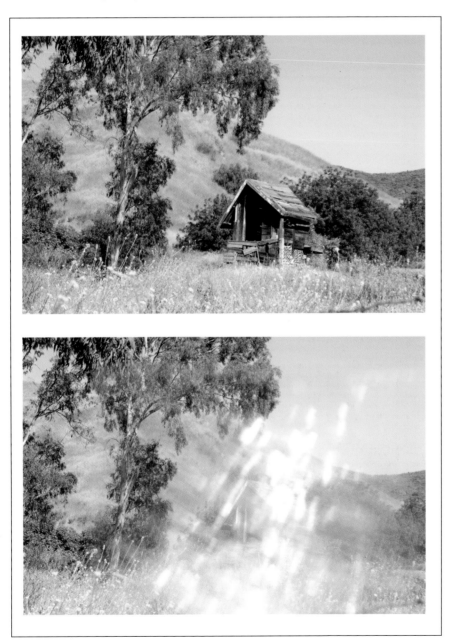

Julie Sparks Andrada used a piece of scratched plastic to create specular reflections that masked areas of the original scene (top) while allowing some background to show through (bottom).

CONTROL

A CONCEPT FOR CONTROL

If we know what happens as light interacts with glass, we can model an approach to control the lighting of our subject. We can apply lighting within the light envelope with knowable results. This is a technical approach, and though it is not intuitive, its application opens up the potentials for creativity. If you know the limits of what can be done physically, then your creativity can be used to enrich the visual aspects of the glass.

This engineering-like approach defines the tools as a means to enable the completion of our ideas. However, as you use this approach, you need to remember that just because you have a hammer does not mean that everything is a nail. Knowing how to use only one tool will not satisfy your every lighting need. Rather, you will need to use various available tools to control the way light interacts with the glass. We control the intensity of the light (add or subtract light), reflect the light and/or change its quality, and the specularity of the light, by spreading or concentrating the light into the light envelope and onto the glass.

WE CAN APPLY LIGHTING WITHIN THE LIGHT ENVELOPE WITH KNOWABLE RESULTS.

GLASS LIGHTING PRINCIPLES

Glass presents two problems that make it difficult to light and photograph: the first is the reflective nature of its surfaces, and second is the way it transmits light. To effectively light our subject, we must develop wanted reflections and eliminate unwanted ones. We must also control the light that is transmitted through the glass. There are several standard approaches to solve problems associated with lighting glass; however, understanding the basic ways that light interacts with glass gives you an expanded selection of approaches.

Reflection. Of the two light interactions with glass, the easiest to deal with is the reflection of light from its shiny surface. Light acts the same when it reflects from glass as it does from any other shiny surface, with the exception that only a small portion of the light reflects each time the light interacts with a surface. As explained in the appendix, the Law of Reflection states that the

angle at which the light strikes the surface is the same angle it is reflected away from the surface. The angle of incidence or striking angle is measured from the perpendicular at the point where the light beam strikes the surface. When the light is reflecting from surfaces that are not planar, predicting the reflectance is more difficult.

As surfaces bend or are faceted the light angles cause the light to reflect beyond a simple mirror reflection. When the surface is not planar, each individual facet or portions of a curved surface reflect the light depending on individual angles to the light. In other words, since the light reflects based on the perpendicular, the angle of the reflected light changes as the surface changes.

Further complicating our task of lighting our subject is the fact that all glass surfaces reflect light. Because over 90 percent of the light reaching the surface enters and passes through the glass, the light entering the glass strikes interior surfaces and reflects in relation to the angle of incidence with the interior surfaces. Since the interior surfaces reflect light directly and from other interior reflections, the interior surface can create multiple reflections from a single light source.

Though it is easier to see the reflections of specular light, diffuse light follows the same rules. Because of its broader nature, however, diffuse light reflects as large patterns of light on all surfaces of the glass. Light coming from a large and bright diffuse source will create larger, brighter, and more intense reflections on glass surfaces. A bright reflection on a front surface (a camera-facing surface) will obscure detail or diminish visibility through the glass. Small or specular sources produce small areas of reflection.

Large, bright light sources will also create large reflections on inside surfaces. The larger the angular variation of the light striking the subject, the larger the light's reflection and the more diffuse the source. A large source that is very far away will have the light arriving at the subject with a small amount of angular variation, creating small reflections and specular light. The same large light source, when near the subject, has great angular variation creating large reflections and more diffuse light.

In addition to the size of the light source, the shape of the source will change the reflections and effects that are produced on/in the glass. A diffuser

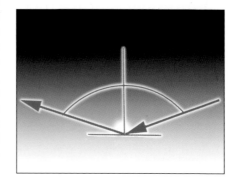
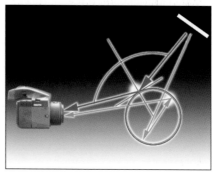

panel can be shaped to create a particular reflection on the glass. If, for example, you wish to have the lighting of the glass look as though it has been created with window light, a cookie (also called a kookaloris) with a pattern similar to a window frame can be placed over a diffuse light source.

The reflections can be controlled beyond size and shape. Just as the light can be patterned to create specific reflections in the glass, the tonal quality of the reflection can be modified to show color or tone beyond an even-toned reflection. The pattern of light in/on the glass will vary when reflecting an area of the light envelope that has a changing tone or color creating it.

Also, any light shining onto a reflective glass surface can reflect directly into the camera from both the outside and inside of the glass. When directional light is used, hot spots (speculars) are unavoidable, particularly with a surface that has a lot of facets, curves, and distortions. If highly directional light is illuminating the glass surface, the speculars are increased, regardless of the subject's surface shape. Therefore, direct light on a glass should only be used when speculars are desired or can be tolerated. Beyond the speculars that are created on the glass, these become flare-producing light sources.

Transmission. The second major optical interaction that affects your photographing glass is that the light can pass through the subject. As the light transmits through glass, the larger portion of the light will refract, or bend. Most of the light will pass through the glass after bending, and a small portion will reflect. For most glass, only about 4 to 5 percent of the light striking the surface will reflect. When the light bends and emerges from the glass, it can be recorded or act as a light source of its own within the light envelope.

Beyond the aspect of refraction as the light passes through the glass, the glass absorbs some of the light. Colorants in the glass are obvious in their filtering of the light. When light transmits through glass, there is absorption of a portion of the light. The thicker the glass, the more absorption occurs. Also, the deeper the color and/or the darker the colorants, the more filtration will be seen.

Lastly, the light will refract and/or disperse as it travels in and out of the glass. This means that light can separate in its wavelengths (the way it is rendered by a prism), or that the light bends at different amounts as seen in focusing for infrared compared to visible light photography.

The light passing through rounded or faceted glass reacts the same as passing through a lens or prism. A specular light shining directly onto a rounded or faceted glass will pass through a pattern of redirected or focused light on other areas visible in the photograph. It is also possible that the light will disperse from facets, producing small spectral patterns in the scene. These light patterns are also created by diffuse light, though the patterns created are not as noticeable.

To best photograph glass objects, we must develop a light envelope in which the light sources interact with the glass in such a way so that visual or

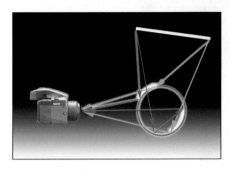

Above—When a broad, diffuse, light source is reflected from a glass cylinder, two broad reflections will show in the image. The first will be seen on the outside surface on the side that the light is placed. The larger the light's surface, the larger the reflected pattern on the glass. The size of the light is defined by its angular coverage, not just the physical size. A physically large light source will have a smaller angle of coverage and produce a smaller reflection. Beyond the reflection on the outside, there will be a reflection on the opposite side on the interior of a glass cylinder. **Facing page**—In this image, a window-shaped cookie was used to create what appears to be the reflection of a window. A thin vertical reflector was used on the left without additional light, and light was aimed at a reflector above the subject in order to create the rim reflection. Photograph by Glenn Rand.

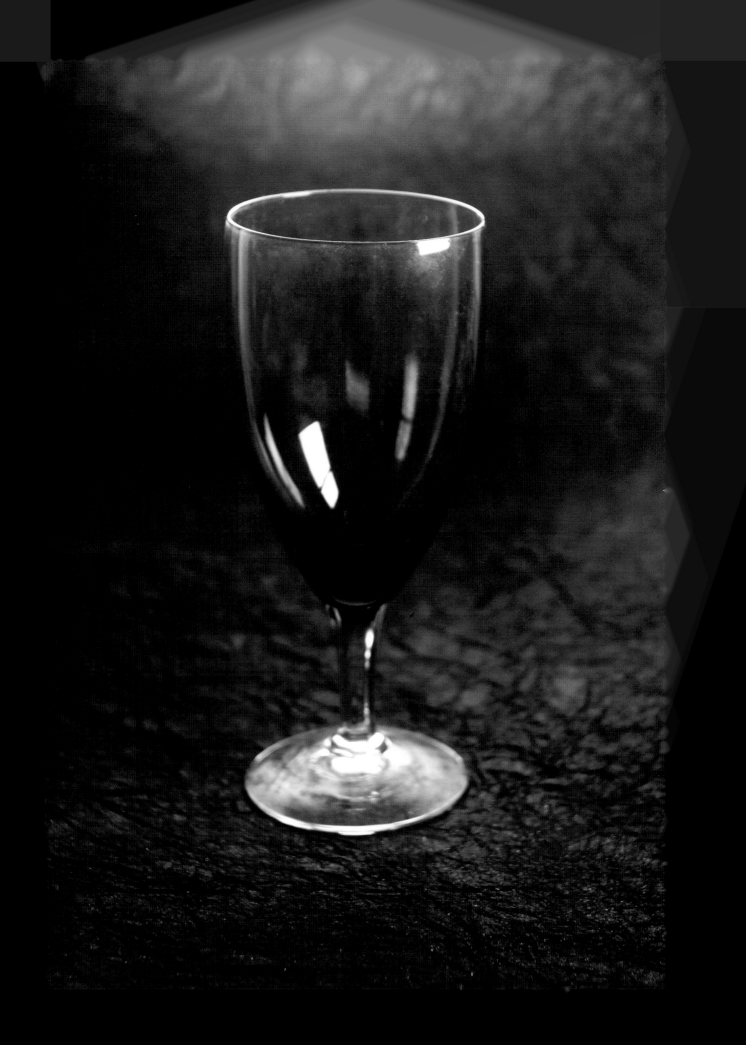

Photo by Neil Rankins.

exposure problems do not result. We can use either of two lighting types to produce the desired effects. Most commonly, the light used to illuminate the subject is diffuse. For the most part, the larger and closer the light or reflector is placed to the glass, the more diffuse the light. Though less commonly used, there are instances when specular light will be used in the light envelope—particularly for accent. Its use must be carefully controlled, however, because specular light can cause many problems when photographing glass.

It is important to remember that all light within the light envelope, regardless of its qualities, will interact in some way with the glass subject and can cause wanted and unwanted effects.

A second concept that has wide use in lighting glass is that lights and lighting materials, particularly fills and reflectors, are best placed to the rear of the light envelope. When light interacts from the front (the camera side) of the subject, it can cause larger reflections on the glass that will cloud or disrupt other lighting effects.

Since we are concerned with all the light shining on objects or light control materials, the setup of a studio can influence the quality of the lighting of glass objects. The darker the studio, the more control you will have in creat-

Here we have an image of a frosted ICE bottle in a field of ice cubes. With the light on the camera side of the set, white reflections show. Photograph by Joe Lavine.

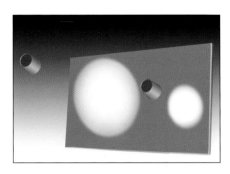

ing the light envelope. Neither digital sensors or film are exposed by black; only light sources or lighted patterns in the studio can be reflected or transmitted by the glass.

LIGHT INTENSITY

The brightness or intensity of lights used in the envelope greatly affects the look of the photograph. Therefore, the ability for the photographer to modulate the light becomes key to achieving a quality image. Light intensity can be increased or decreased, and it is typically modified in four ways: (1) via power controls on artificial light sources, (2) by blocking or partially blocking the light, (3) by using the Inverse Square Law, and/or (4) through exposure (this will be discussed in chapter 4).

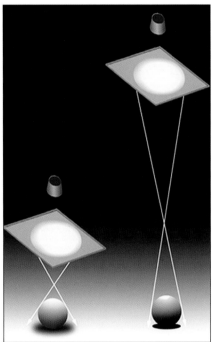

For many people, the easiest modification to understand is the electrical solution. Some light units offer controls, like a rheostat on a continuous light or a variable capacitor on an electronic flash unit, that allow you to adjust the intensity of the light output.

There is an often-overlooked control in all lighting: the on/off switch on the light unit. Overlighting glass can cause problems. Just because a photographer has many lights at their disposal does not mean that all of them need to be turned on. Be sure to use the "off" position for the light switch when in doubt.

The second way to control the light intensity is by blocking, feathering, or vignetting part of the light source. This blocking can be complete, as with a gobo, or partial, with scrims, grids, or gels. Also understanding the light pattern created by light units allows the use of "off-center" portions of the light that create softer lower intensity. With transparent and translucent materials understanding these "off-center" portions of the light beam aid in creating the best light envelope for your subject.

Another way to eliminate unwanted light is by using gobos. A gobo is a device that is placed between the light and the subject to block light from entering the light envelope. For glass, it is best to use a gobo with the black side facing the subject. This does two things in the creation of the light envelope.

Top—According to the Inverse Square Law, when two identical spotlights are placed in front of a board, one at a distance of four feet (left) and the other at a distance of two feet (right), the intensity of the spotlight placed two feet from the board will be four times brighter (two stops more light) than the spotlight positioned at four feet. In other words, if the reading on a light meter in the left light pattern is f/4, the reading in the right light pattern will be f/8. **Bottom**—If the light striking a diffuser is kept at a constant, but the diffuser is moved farther from the subject, the light will become more specular. Remember, the more diffuse the light, the softer the shadows and the broader the reflections.

First, it blocks the light from entering the envelope, and second, it prevents the illumination from other lights from bouncing off of the gobo, which might be seen as a reflection in the glass. In its latter role, the gobo acts as a flag (a dark, normally black, panel or object placed in the light envelope to absorb light and minimize reflections).

Intensity can also be modified by adding light. It is easy to think of adding light to the envelope by using additional light sources, but there are less intrusive ways to add and manipulate the light intensity. This can be accomplished by using reflectors. Reflectors can be highly reflective or matte. A highly reflective reflector, like a mirror, can be used to add specular or diffuse light, depending on the quality of the light striking it. A matte reflector will only create diffuse light. Keep in mind that reflected light can cause reflections on the glass just like any other light source.

Photograph by J. Seeley.

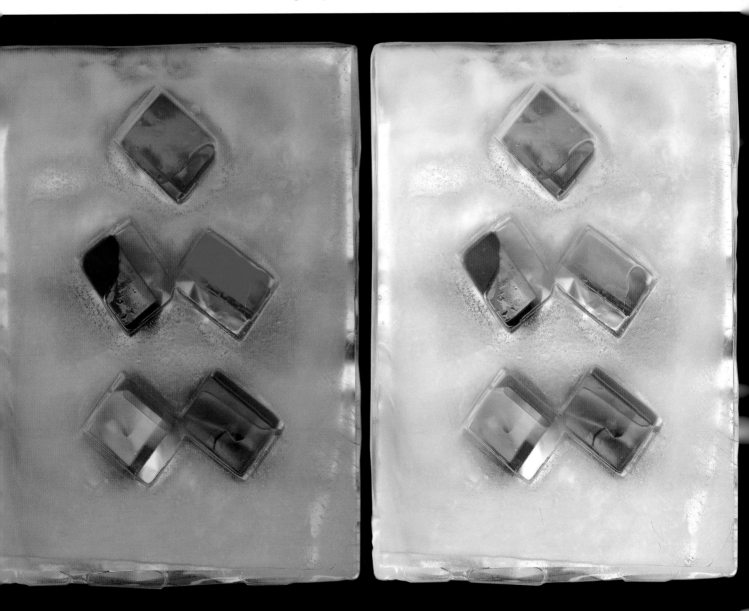

Photograph by Dan Wheeler.

Light intensity can also be increased by using a special tool (e.g., a Hose Master) or a snooted flashlight for the duration of the exposure. When using such a device, it is important to ensure that the color temperature of the light source matches the color temperature of the other light sources that make up the light envelope.

Another means of modifying the light intensity on a scene is to use gels, screens, scrims, baffles, snoots, and barndoors. Keep in mind that using gels will impact both the intensity and the color of the light source.

The third way to modulate the lighting intensity is by using the Inverse Square Law. The law, which describes the relationship between a light source and its intensity when placed at varying distances from the subject, states that the illumination from a point source of light falls off inversely to the square of the distance. For example, when a light positioned ten feet from a subject is moved to twenty feet, it will have only ¼ the original lighting intensity. Conversely, as the distance is reduced, the light increases in intensity. Since both photographic stops and this law are based on a mathematical square function, it can be said that when you double the distance between the light source and the subject, you lose two stops. If you halve the distance, you gain two stops, resulting in four times the intensity. The exposure of the reflected

USING GELS WILL IMPACT BOTH THE INTENSITY AND THE COLOR OF THE LIGHT SOURCE.

intensity does not vary with the distance of the subject from the camera, only varying distance between the light source and the illuminated surface.

Multiple Sources. Lighting glass may require multiple light sources, each with its own control. In such cases, an undesirable buildup in intensity can occur—and this is a particular problem when using digital capture or transparency film, as neither is as tolerant of overexposure as negative film. In such cases, intensity control is especially critical.

Regardless of the number of lights being used, seldom should these lights shine directly on the subject.

CONTROLLING THE QUALITY OF LIGHT

If a light is shown on and through a translucent material or reflected off a large fill card, it will strike the subject from numerous angles, producing a larger, more diffuse lighting effect and larger reflection (if seen). It is important to note that any change in the quality of light used in the light envelope will affect not only the glass but other items or subjects within the scene.

The degree of diffuseness of the light is not due only to the size of the light's surface but also depends on its distance from the surface it strikes. The largest light source normally used for photography is the sun. Though it has a large light surface, it is far away from the earth and thus becomes a specular source.

SPECULAR LIGHT CREATES DARK SHADOWS; DIFFUSE LIGHT CREATES SOFTER SHADOWS.

The term "specular" comes from the bright specks (such as a hot-spot reflection a spotlight produces on the rim of a drinking glass) that form on highly reflective surfaces from point source lights. Specular light creates dark shadows; diffuse light creates softer shadows. When photographing glass, the specular concentration of light can cause problems. The closer the illumination is to a point source light, the more noticeable the hot-spot reflections. When specular light interacts with curved or faceted glass, it can be refracted or dispersed as it transmits through the glass. This may be seen in the scene or cause other unwanted reflections or hot spots.

CHAPTER THREE

WHITE-LINE AND BLACK-LINE LIGHTING

Reflection and transmission of light create the major lighting styles for glass. Though the effects of lighting glass may be seen in all areas of the glass, the two major forms of lighting glass—white-line and black-line lighting—are defined by the way the light is seen at the edge of the glass. It can be argued that all lighting of glass is one of these two types of lighting, or a combination of both.

If there is a bright light on the side and/or on the surfaces of the glass subject closest to the camera, then the lighting is known as a *white-line* lighting pattern. When the light passes through the glass, some of its intensity is absorbed by the glass, and there are no reflections on the camera-facing surfaces, a *black-line* lighting pattern is created. White-line and black-line lighting are seldom pure. Normally, part of the lighting will have one characteristic and other portions will reverse.

The two forms of lighting glass can provide different information about the glass. With attention paid to the edges of the glass, both give good defi-

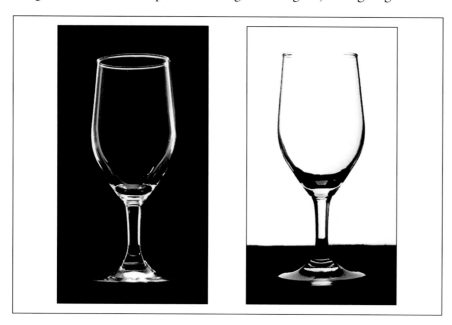

Left—White-line lighting is based on reflections. Understanding the concepts involving reflections allows us to place varying amounts of reflection on specific parts of the surface of the glass, helping to show the volume and form of the glass. **Right**—Black-line lighting exists because the light is transmitting through the glass. Because it absorbs portions of the light, the glass acts as a filter, showing the color, density, and thickness of the glass. Unlike a white-line lighting pattern, a black-line pattern tends to flatten the visual space within the glass.

Above—David Ruderman used pure black-line lighting to show the unique color of each bottle. **Right**—In this image, the concept is to show the various tones of each beer. To do this, a black-line lighting pattern was created by backlighting the glasses. The reflection from the waxed table projects the light up through the glasses toward the camera. Photograph by Joe Lavine.

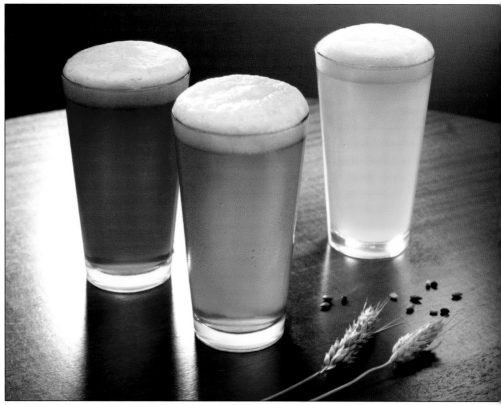

nition of shape. The contour of the glass is the most important quality in defining the subject. Since both white-line and black-line techniques can render good contour, neither is superior for that use. There are, however, two critical differences in the way the lighting looks and how we can use it to meet our needs. We'll address these in "Determining the Proper Approach."

CREATING WHITE-LINE AND BLACK-LINE IMAGES

There is only one controlling factor in determining which type of lighting shows on any portion of the glass—the background. A white-line effect is achieved when the reflection on the glass is brighter than the background. A black-line effect is achieved when the background is brighter than the reflections on the glass. In this case, the lighting pattern will show color, tone, and density.

Note that "background" refers not only to a fabric or paper used behind the subject, but to any area to the rear of the glass or objects that can be seen behind the glass. It also refers to the amount of the light in the background, and not just the absolute reflectivity of the materials that appear in the image. If a white object behind the glass is unlit, then it is likely that white-line lighting will occur; a dark background with bright lighting may well create a black-line lighting effect.

DETERMINING THE PROPER APPROACH

The lighting approach that will work best for your glass subject depends upon its qualities and features. As a general guideline, remember that white-line re-

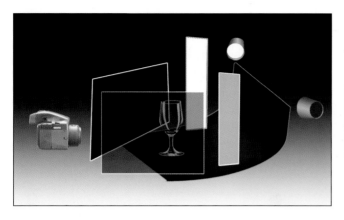 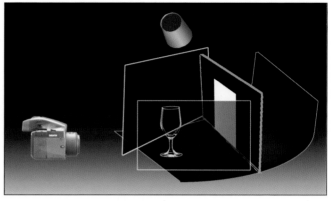

Left—A classic white-line image is created by placing a vertical fill card on either side and to the rear of the glass. Each card is separately lit, controlling the light so that none of the light shines directly on the glass. The farther back the cards are from the glass and the closer to tangent with the surface of the glass and the line from the camera to the cards, the closer the lines will appear to the edges of the glass. The narrower the cards and the farther they are from the glass, the thinner the line will appear. The intensity of the light on each card will change the intensity of the reflected line, and even if only one card is used, the internal reflections will make it appear that there are lines on both sides of the glass. **Right**—Creating a tight and dark light envelope with only a diffuse light surface directly behind the glass creates basic black-line images. If the lit panel receives light from the front, the light should be controlled to prevent direct light from shining on the glass. If the lit panel is too wide, it will create white lines on the edges of the glass and can cause added lens flare. To reduce reflections from the front surfaces, black matte cards (flags) are positioned to allow only a small space for the camera to view inside the light envelope. The exposure for black-line images is critical because the camera is facing a light source. If there is over-exposure, the tone created by the density of the glass will be lost, and the dark lines on the edges will be weak.

flective effects on the subject's outer surfaces can provide visual clues that help the viewer perceive the volume of the glass. In black-line lighting, light passing through the glass gives a good indication of outside contours and emphasizes colors or densities of the glass or transparent/translucent materials.

By compositing two images of your subject—one taken using the white-line technique, one taken with the black-line technique—you can reap the benefits of both approaches and maximize your images. Though it can be accomplished with film, compositing images using an image-editing program's layers feature simplifies the task. (This will be discussed in chapter 7.)

CASE STUDIES

For the following examples the same basic subject arrangement has been used. This will allow the comparison of the difference between white- and black-line lighting. In each photo session, the primary consideration is the color of the glass. A white-line lighting pattern was used to photograph a clear glass, and a black-line approach was used to photograph a glass with a light colorant.

White Line. This example uses classic white-line lighting to accent the shape, volume, and the sandblasted decoration of the glass. Since the glass has no colorant, using the white-line approach will make the glass look clearer and cleaner.

Adding a flower to the scene adds complexity since, if we are to add light on the camera side of the flower, we cannot use the same lighting that will be applied to the glass. Also, when light is applied to the flower, it can be difficult to keep specular reflections from appearing on the glass.

Right—This photograph shows the classic white-line approach with a flower in the glass vase. The sandblasted design on the vase is a diffuse surface and therefore will spread and scatter the light in the light envelope to the camera. Glass used for this photograph was by Mary Marshall of Crystal Glass Studio in Carbondale, CO.

Diagrams—**(top left)** A white-line approach helped to define the shape of the vase and put light into the sandblasted areas while maintaining the contrast in these areas. Black Plexiglas was used to give a reflection of the glass toward the camera and to allow reflection of the lighting controls into the glass from below the glass. This allows for the white line to wrap around the bottom curve of the vase. A black background was used behind the subject to prevent unwanted highlights from appearing in the glass. **(top right)** The classic white-line lighting was created using tall, thin fill cards on each side of the glass. Each fill was positioned behind the glass in relation to the camera and lit with a spotlight that was controlled to avoid direct light reaching the vase. The left-side fill card was given more by positioning a light closer than a card. This created the differential in the light intensities on each side of the glass. Since the background is black and the vase is placed on black Plexiglas, the reflections (the white lines) in all parts are bright. The left-side highlight was metered using a spot meter. The aperture was opened up three stops, to set the reflection as white. **(bottom left)** Flags were placed and angled away from the camera on both sides to keep reflections from appearing on the front surfaces of the vase. **(bottom right)** Finally, the flower was lit separately to prevent additional light from reaching the glass. The flag on the flower's spotlight was used to focus light on the flower and keep it from falling on the vase. The spotlight on the flower was repositioned to equal the exposure needed to set the white lines. An incident meter was positioned at the flower and pointed at the spotlight used to illuminate the flower.

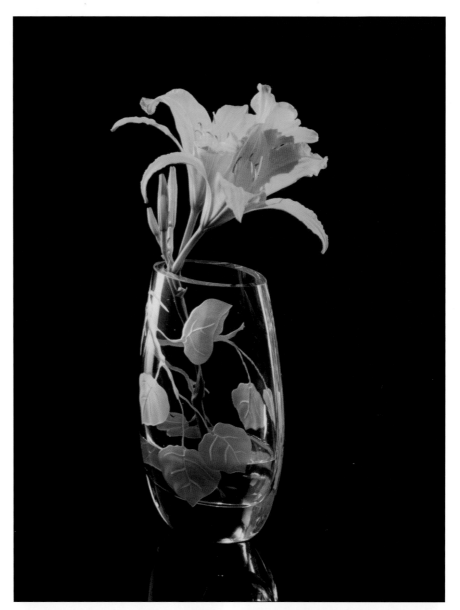

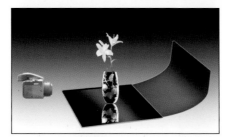
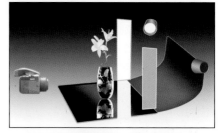
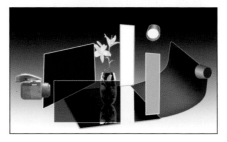
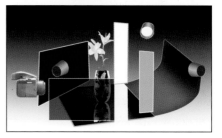

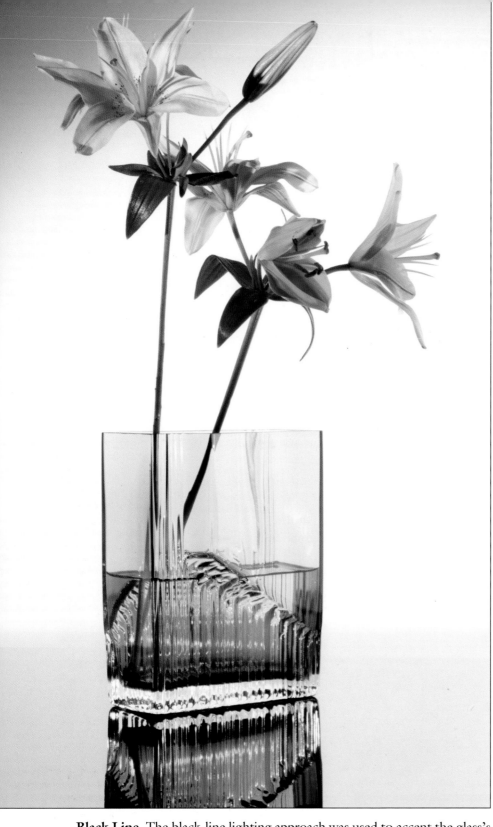

Black Line. The black-line lighting approach was used to accent the glass's color, and specular highlights accented the textural decoration. As in the previous example, the flower adds a second level of complexity and will be handled in a similar manner as in the discussion of white-line lighting. Unlike the classic white-line example, specular highlights and surface reflections were added on the glass.

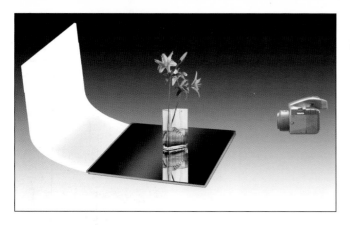 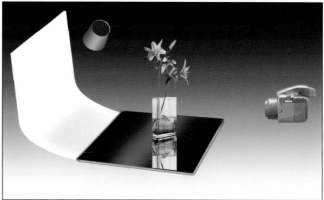

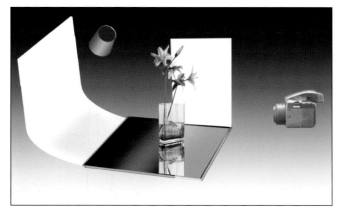 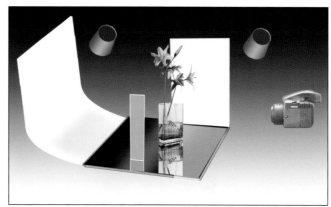

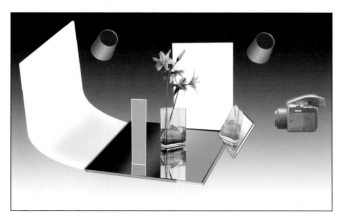 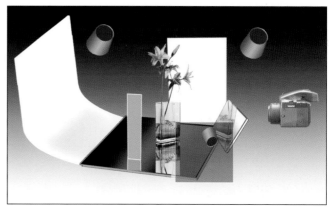

Diagrams—(top left) The overall black line effect is created by the large white surface behind the glass. For a consistent look, black Plexiglas was used here, as it was in the white-line example. The Plexiglas has a polished rear edge to soften the reflection and eliminate a sharp line. With limited depth of focus, the back edge will soften further. The camera is positioned low to move the line across the back into the patterned area of the glass. **(top right)** The background is brightly lit with falloff at the top ensuring even light behind the subject to create the overall black-line treatment of the glass. Exposure is determined by taking a spot meter reading through the glass and opening up one stop to give the glass a lighter tone. This will allow us to show controlled reflections, and specular accents allow the viewer to perceive density differences in the glass. **(center left)** A large white fill card was positioned to reflect light into the left plane of the glass, and a spotlight was shone on the card. The intensity was adjusted to give a slight reflection on the glass that would not mask the color of the glass. **(center right)** A tall, thin white card was placed on the right side to create a slight reflection. No additional light was used on this card. Without extra light on this card its intensity will be less than the large fill card on the left side of the set. Because this card is receiving less light, its reflection will be less powerful on the right side, accenting the corner shape of the glass. **(bottom left)** To produce the specular accents on the modeled portion of the glass, a mirror was placed in the beam of the spotlight on the left side of the set. The mirror was aimed upward so that the shadow pattern created by this light source would not be seen in the image. Because the surface of the glass catching the light from the mirror was flat, any light reflecting from the surface went to the ceiling above the set, not toward the camera. **(bottom right)** Here, a small spotlight was shown on the flowers. A gobo was used to ensure that no light from this spotlight would show on the glass. An incident light meter was used to measure the light at the flowers, and the light was moved to a distance to match the exposure for the black line.

Combining Line Effects. The photograph below illustrates the use of black-line technique to show the colored glass and white line, diffractions, and reflections to accent the edges of the fins of the glass fish to bring out the dichroic color of the fins.

 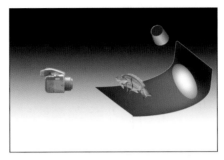 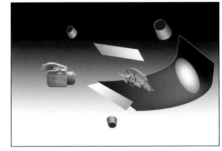

Diagrams—(left) The photograph was made in a totally darkened studio. A dark-gray seamless backdrop was set up with about a six-foot sweep from the subject to the vertical back. **(center)** A spotlight was focused to form an oval of light on the background. The shape was controlled so that the top edge of the light pattern would fall off aligned with the fins' shape. Even though the backdrop was dark gray, the intensity of the light was strong enough to record as very light gray during exposure. The light gray background light pattern will allow a black-line treatment for the colored glass. If the background were black, it would not allow enough reflection of the spotlight to see the color of the glass. If the background were white, the falloff would not be great enough to accent the edges of the fins. **(right)** A spotlight was aimed at a long, white fill card above and in front of the glass fish. This reflected light off of the top fin, showing off its dichroic glass and creating front/top white-line effects. With the light pattern on the background aligned with the top edge of the glassware, it provided a strong white-line effect for the top fin. The spotlight was feathered to create falloff on the white card so that the card was brighter toward the rear of the fin. The varied light created better color in the dichroic glass. A second spotlight was aimed at another white fill card positioned below on the camera side of the glass. The card was positioned so that the light would be brighter and closer to the fish's mouth. This was used to create reflections on the bottom details of the fish. Since the intensities of the reflections were brighter than the background light pattern, they show as white lines and reflect off the silvered mouth.

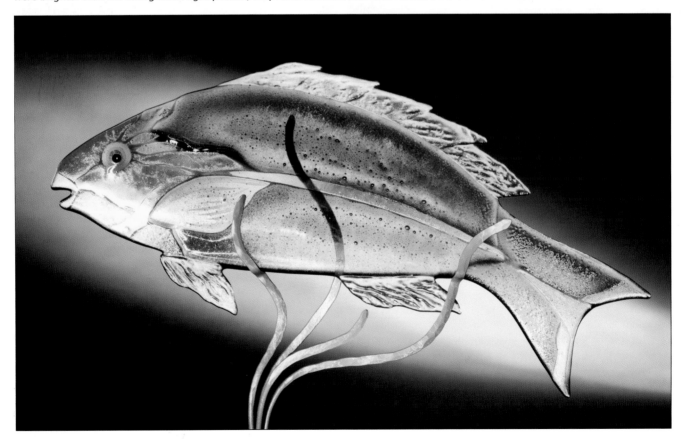

Glass fish by Mary Marshall of Crystal Glass Studio in Carbondale, CO. Photograph by Glenn Rand and Mary Ehmann.

Below left—Bob Coscarelli produced this image using a common trick to accomplish the black-line effect for the color of the perfume and the white-line effect for the facets of the bottle and stopper. Gold foil cut to the shape of the bottle was placed between the bottle and blue background. The allowed light to reflect back through perfume, showing its color and creating the dark patterns. At the same time, the perfume and background are darker than the reflections on some of the facets of the bottle allowing the bright reflections.
Right—The glass at the rear of the image was backlit showing the color of the beverage. This is a black-line pattern. Front light was added to illuminate the label and to create a white-line effect on the condensation on the bottle. A small light was brought through the bottle, and because of the dark color of the glass, the glow in the bottle is weak. Photograph by Joe Lavine.

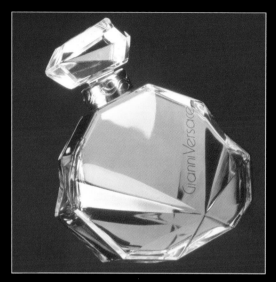

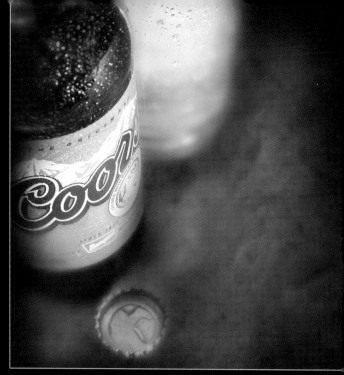

Below—This approach uses a basic black-line technique with the Tiffany glass lit by a lightbulb from behind. Photograph by Douglas Dubler.

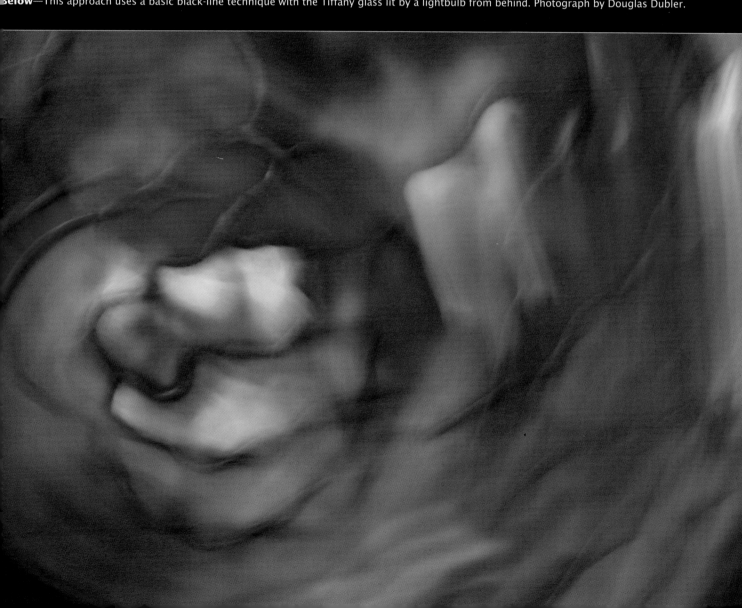

EXPOSURE BASICS AND METERING

Good photography is dependent on good exposure, and good exposure relies on good metering. Though there are photographers, particularly those who work with digital, who say that metering is unimportant because bracketing can ensure proper exposure, it is likely that the best exposure, particularly with transparent and translucent materials, will not come from this "hit or miss" approach.

Because we are dealing with illuminating the subject, including but not limited to the glass, and creating the reflection in/on the glass, achieving a proper exposure is important for ensuring the subject looks its best, as well as for producing reflections, or a lack of reflections. Metering allows you to balance the light in the image to achieve the required look or to create an exposure showing the subject and reflections in their proper relationship.

In the following pages, you'll learn about exposure and exposure control and will read tips for metering to make the most of your photography.

DIGITAL CAMERAS AND TRANSPARENCY FILM DO NOT HANDLE OVEREXPOSURE WELL.

EXPOSURE CONTROL

Though most of this book pertains to the quality and control of light that is needed to photograph glass and other light-transmitting materials, exposure control is very important. Digital capture devices and transparency film do not handle overexposure well, so care must be taken with the exposure and lighting to avoid these problems.

For many subjects, incident or reflective meters—or even a digital camera's histogram—can be used to guide exposure decisions. For glass, however, a spot metering system provides the most accurate exposure information. The spot meter can measure the amount of reflection and/or transmission of light, factors that are more important for the look of the glass than the amount of light striking the glass subject. With a spot meter, exposure can be set to record the desired tonal responses to the light that reflects from and transmits through the glass. An incident meter reading or average meter reading will not give this control.

Facing page—The image was created by adding food color to glycerin and then photographing through the liquid on a light table. Photograph by Neil Rankins.

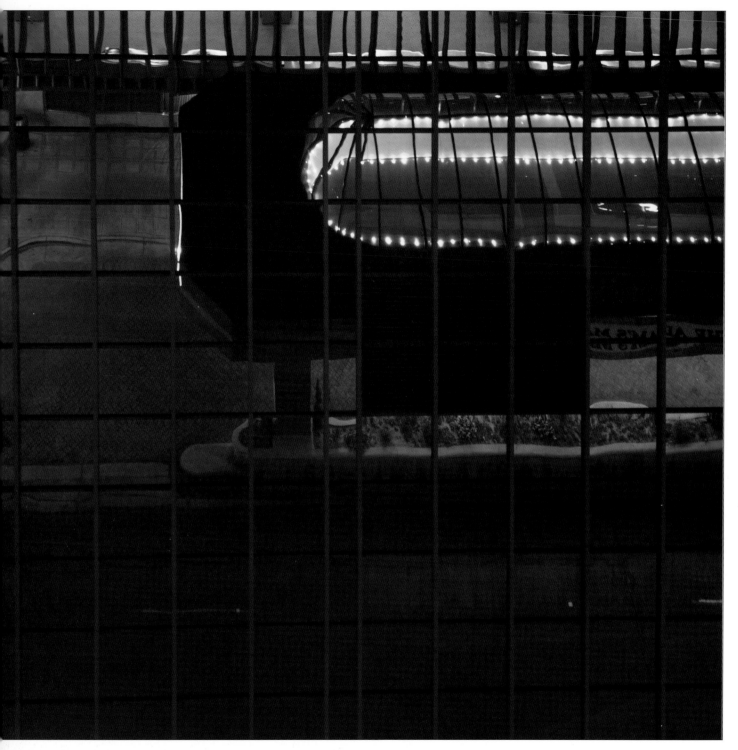

Some photographers believe that their camera's histogram can prove useful in determining proper exposure for glass. Though the histogram will show the amount of light recorded at any illumination level, it does not delineate where in the image any specific light exists. Though the histogram and LCD screen are useful for proofing the shot and adjusting the settings to achieve correct exposure, it is a time-consuming venture and does not address the issue of building an appropriate light environment for the glass.

This image was made looking at a downward angle toward a building across the street. Windows reflected the front of the hotel. The hotel had a glass dome over its entry. The ground below the entryway was brighter than any reflections on the glass dome, thus the dome's glass does not show in the image. Photograph by Glenn Rand.

Difficulties compound when the photographer needs to address glass and other materials in the same image. This is because the lighting requirements for non-reflective and non-transmitting subjects are different than those for capturing the interactions of the light with the glass. For most situations, the light envelope for the glass will need to be constructed first, with the exposure for the glass determined based on these limits. The photographer can

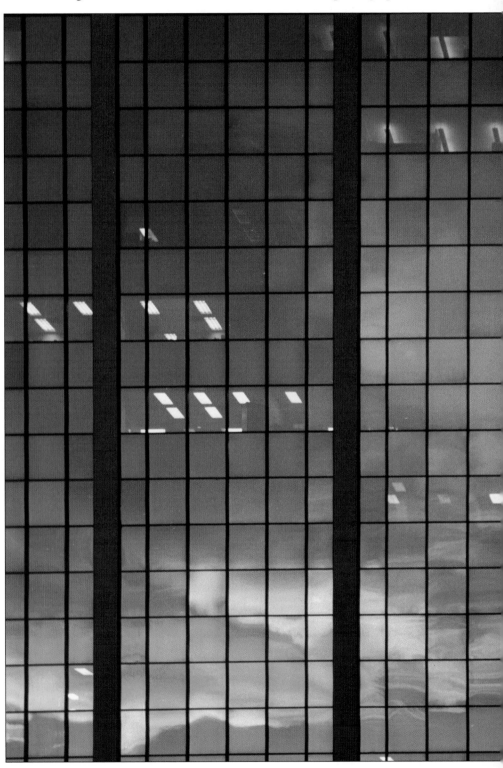

Photograph by Michael Rand.

then adjust the lighting for other subjects within the image to match the exposure determined for the glass.

EXPOSURE LATITUDE

The term "exposure" refers to the act of light striking a photosensitive material and recording an image. Exposure is variable, and photographers make certain calculations to ensure an image has a range of tones from pure white to pure black, and that texture/detail is preserved in the image elements.

Facing page—This American flag was backlit, rendering the red and blue areas translucent. Because the stars were stitched rather than printed onto the fabric, they appear dark in color rather than white. Photograph by Victoria Ruderman.

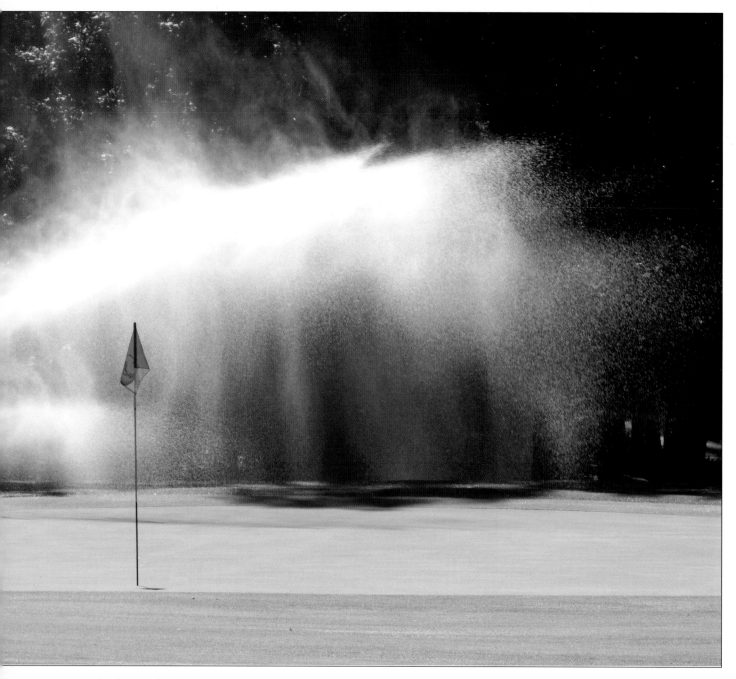

Since the flag was backlit and had a background of highly reflective, bright, spraying water, light was transmited through the thin red nylon flag and created a black-line effect. At the same time, the water, against the dark background, created a white-line image. Photograph by Glenn Rand.

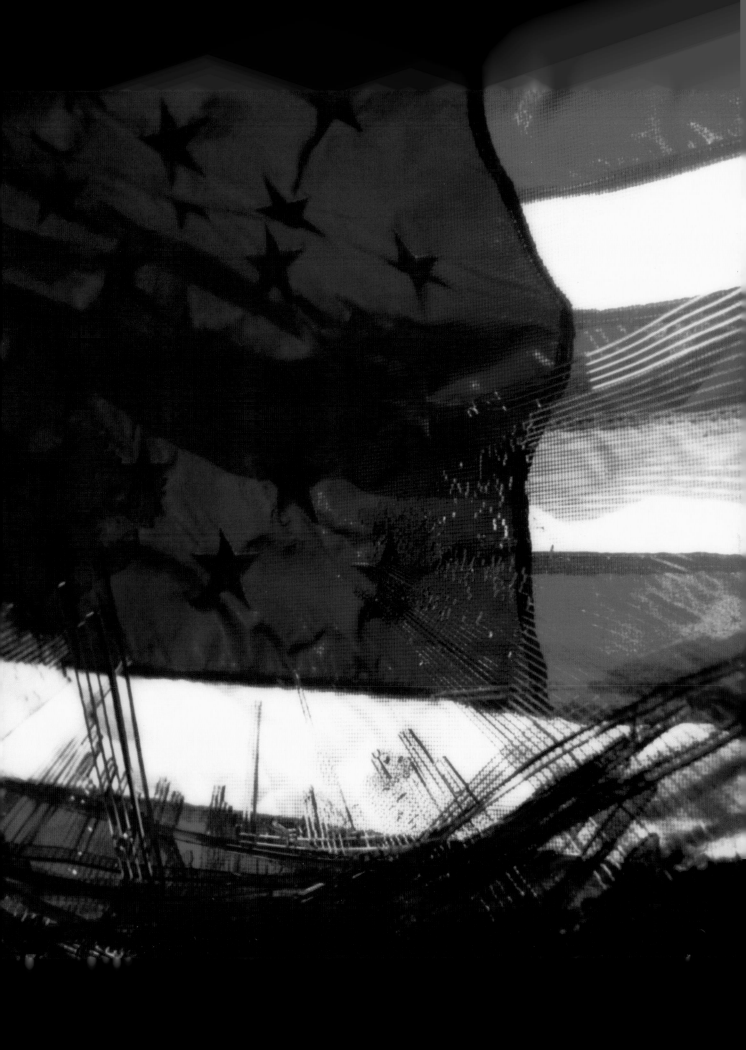

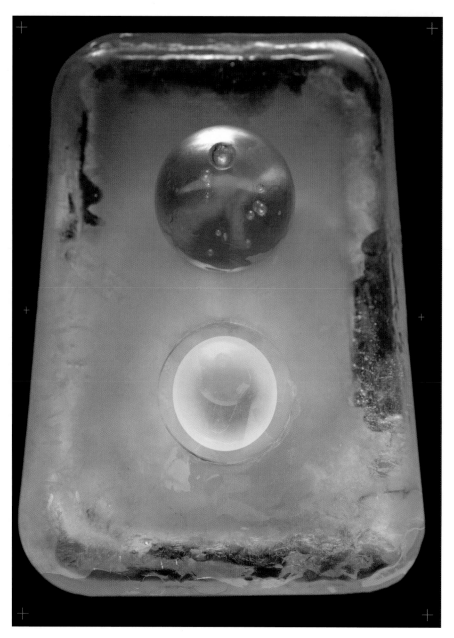

A block of ice with embedded balls was placed on a flatbed scanner. The warm color seen in the image comes from incandescent light coming into the scanner. Photograph by J. Seeley.

The various photosensitive materials have differing tolerances to very light or very dark tones. Negative films (both black & white and color), for instance, have a greater "latitude," meaning that they can capture a wider range of tones than either digital image sensors or transparency film can. However, when photographing a subject or scene on negative film, care must be taken to properly expose shadow areas, as the medium is better equipped to adequately record the highlight areas in overexposed frames than to record detail in very dark, underexposed images. Transparency film and digital image sensors are not as tolerant of overexposure and are noisy in very dark areas of exposure.

THE VARIOUS PHOTOSENSITIVE MATERIALS HAVE DIFFERING TOLERANCES TO VERY LIGHT OR VERY DARK TONES.

The simple equation that defines exposure states that exposure (H) is equal to the Illumination (E) times Time (T).

$$H = E \times T$$

This means that there are two variables that affect exposure: the illumination and camera controls (aperture and shutter speed). Though it appears that there are only two variables in this equation, there is one other variable (actually, an assumption) that makes the equation work. This is that the film's ISO speed or the digital camera's ISO setting remains constant.

The light establishes exposure as a relationship between the ISO, f-stop, and shutter speed. These measures show the impact of the Law of Reciprocity on photography. In a nutshell, the law states that as one part of the system is increased, another part of the system must be decreased to keep the system in balance. At the center of the photographic system is a 2:1 ratio. For instance, the amount of light striking the film or image sensor is either doubled or halved when a one-stop exposure change is made. Changing the aperture setting from f/8 to f/5.6 doubles the exposure, and stopping down from f/8 to f/11 halves the exposure. A shutter speed of one second gives two times the exposure as ½ second. ISO speeds/settings are also based on a 2:1 ratio. An ISO rating of 200 is twice as fast as ISO 100.

The Law of Reciprocity allows us to produce a series of equivalent exposures by opening up or stopping down and changing the shutter speed setting accordingly. For example, without moving or changing lighting:

- Holding ISO constant, f/4 at ¹⁄₁₂₅, f/5.6 at ¹⁄₆₀, f/8 at ¹⁄₃₀, f/11 at ¹⁄₁₅, etc., all provide the same exposure.
- Holding the shutter speed constant, f/11 at 400 ISO, f/8 at 200 ISO, f/5.6 at 100 ISO, etc., all provide the same exposure.
- Holding f-stop constant, ¹⁄₁₂₅ at 400 ISO, ¹⁄₆₀ at 200 ISO, ¹⁄₃₀ at 100 ISO, etc., all provide the same exposure.

The variability of ISO settings that digital cameras allow offers another way of controlling exposure not available with roll film. Sheet film, however, will allow this approach with push/pull processing.

The three controls provide the photographer with different ways to achieve equivalent exposures. Because f-stops, shutter speeds, and ISOs are based on a 2:1 ratio, there are many potentials. By holding one of the three controls constant, the other two can create equivalent exposures.

This provides photographers with further control over their exposures. While we can use equivalent exposure when holding the light intensity constant, we can hold the exposure constant while tuning the light. Whether controlling the light's intensity electronically or using the Inverse Square Law,

we can tune the lighting to meet an exposure value. This gives us a great deal of control.

As stated above, the ratio 2:1 is key to controlling exposure. In practice, this means that when we move the light 1.4 times farther from the subject, the intensity of the light is halved. We are working backward with the Inverse Square Law, and 1.4 is approximately the square root of the number 2. When a light is moved 1.4 times farther away, there is half the light or a one-stop loss of intensity. If we move the light twice (2x) as far from the subject, we have adjusted the light two stops, and if we move the light 2.8 times farther away, we have reduced the light by three stops. This relationship holds true for all full stops as multipliers of distance change for the light.

LIGHT METERS

Meters measure the amount of light reflected from the subject (reflective meters) or the amount of light falling on the subject (incident meters). They determine exposure by measuring the light and comparing it to an average tonal representation in the subject. The metering assumes that the measurement is a mixture of light values equaling 18 percent reflectance or representing about 118 in an 8-bit grayscale image in a digital capture.

Reflected light meters measure the light that bounces off the scene or subject. A spot meter, a narrow-angle light meter used to take accurate readings from a small area of a subject, is the best option for determining exposure for transparent materials. Though many cameras feature built-in reflected light meters and read the light falling on the scene through the lens, these meters are not recommended for photographing glass because, to accurately align the reflections or densities in the subject, your camera must remain steady during the preparation and exposure. Therefore, a handheld spot meter is the best choice for precisely metering and determining exposure.

REFLECTED LIGHT METERS MEASURE THE LIGHT THAT BOUNCES OFF THE SCENE OR SUBJECT.

Incident meters feature a built-in diffusing dome that mixes the light falling on it and then read the light. Though this method is useful for many types of subjects, it cannot be used to set exposure for reflections on glass subjects or the transmission of light through transparent or translucent subjects.

Some meters, such as the Sekonic L-758DR, allow for sophisticated measurements that allow the placement of both the reflected highlights and the transmission or shadowing of the glass. With such meters, reflective spot and incident metering can be accomplished with the same instrument.

Some photographers use non-metered exposure (i.e., basic daylight exposure/Sunny 16 rule). Though this technique will work for an overall exposure including glass, it is basically an incident technique based on experience. The approach will have the same limitations as incident metering, because it does not allow critical exposure defining the desired reflections or transmission color of glass.

Top—A spot meter can be used to establish white-line lighting by either measuring the light reflecting from the glass or the intensity of the fills used to create the white lines. In either case, the light meter–based exposure will need to be increased by opening up three stops. **Center**—An incident meter can be used to establish the exposure for a white-line image by reading the light value at the fill creating the white line and using the recommended exposure setting. **Bottom**—Spot metering is the best way to establish exposure for black-line effects. The meter is used to take a measurement through the glass and read the light value from the light source (fill) projecting through the glass. Once a measurement is taken, tonal placement metering is used to establish the tone level for the glass.

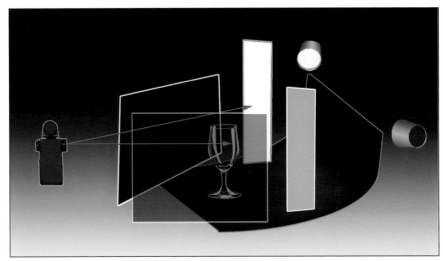

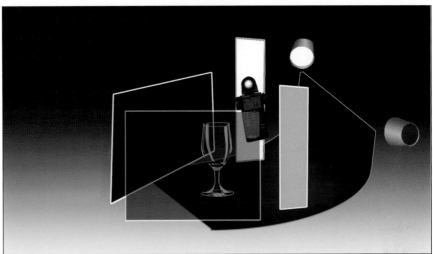

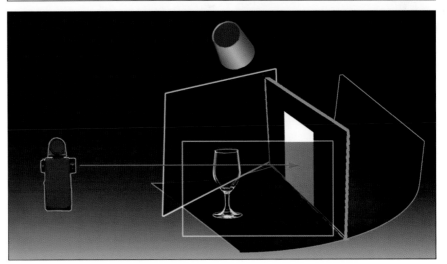

TONAL PLACEMENT METERING

Tonal placement metering is an important tool to accomplish the desired look in our images. In fact, it is the basis of the Zone System. (For more information on the Zone System, see *Film & Digital Techniques for Zone System Photography;* Amherst Media, 2008). The concept is built on the direct

relationship between stops and zones and holds true for all midtones but loses its effectiveness at the dark and light extremes of the light range. The concept holds that a one-stop change in the light or exposure will change the zone value of the metered area one zone. To use this technique, then, the photographer uses a reflected light meter to measure the light coming from a selected area of the image. Since the meter is built to calculate exposure of middle gray, opening up one stop will lighten the selected tone to be brighter by one zone, and stopping down one stop will darken by one zone. When darkening or lightening any specific area within the image, the tones in the rest of the image will shift in the same direction.

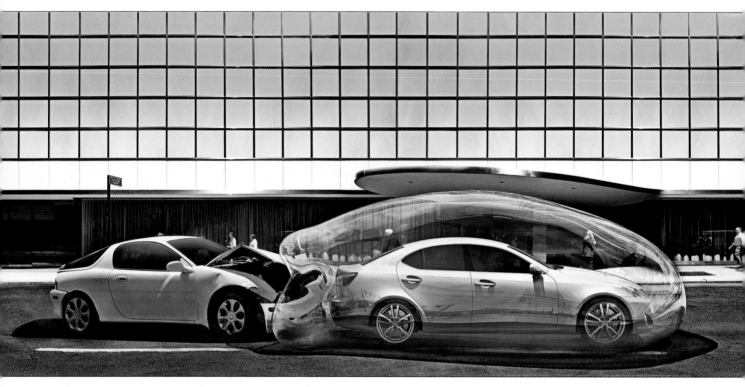

This image does not portray an actual event. It was produced through a process known as "ray tracing." All the reflections and distortions created by the transparent materials were generated in the computer. Along with the reflections on the cars, the artist used the ray tracing process to to create reflections, diffractions, and transmissions for the bubble and the things inside the cars. With the exception of the No Standing sign, the background was made in grayscale, and this intensifies the diffracted colors on the bubble. Photograph by Render Unit/Dave Levine.

Tonal placement metering is the preferred method for setting exposure for black-line images. To use it, take a spot meter reading of the shadow area in the image and stop down to establish the intensity of the black line, or meter through the glass to measure and set the tone of the glass in the image.

To photograph a glass subject using the tonal placement metering, then, you can use the following steps. To ensure that a reflection is rendered white in a digital image, open up four stops from the spot-meter reading of the reflection while holding the shutter speed constant. You would stop down one stop for a dark middle tone or two stops for shadow detail. Normally, the rich color of light transmitting through glass comes from stopping down one stop

from a reflective reading coming through the glass. Since the tonal placement controls only one area in/on the glass, as the chosen tonal area becomes darker or lighter, the other tones in the image will move proportionally in the same direction.

Dark Tone Metering. In this approach, we determine an area of the subject or scene that contains critical shadow detail, take a reflected light meter reading, then stop down two stops to ensure the correct exposure. A common mistake is choosing the darkest tone in the scene. When black is measured and then lowered two stops, it assumes the black has detail since it is actually at least two stops overexposed because black was misread as shadow detail. With digital photography this error should be avoided since digital sensors do not tolerate overexposure. It is helpful if there is detail that is critical in a black-line effect, a subject with shadow detail in the scene, or in images where there are few highlights as compared to shadows, or when highlights are unimportant in the image. If shadow detail is critical and is not captured in an exposure on film, it will not be present or will appear as noise in a digital image.

Highlight Detail Metering. Highlight exposure is the flip side of dark-tone metering. This is most useful for white-line glass lighting. It is also effective and desirable for digital capture. Where the intensities of reflections are important, it is a good choice to select a highlight detail area as a consistent metering point. Like dark tone metering, this technique is a specific application of tone placement. You select the area in the scene that you wish to be a certain highlight value or white, meter the area, then adjust the exposure by opening up two stops for a bright tone, or three stops to make the area appear whiter. This is the method used to establish the level of reflected intensity for white-line images.

Average Value Metering. Within the light envelope there are generally both highlight and shadow details that the photographer will want accurately presented in the image.

To use average-value metering, follow these simple steps:

1. Determine the area that requires highlight detail and take a reflected light meter reading.
2. Determine the area that requires shadow detail and take a reading.
3. Choose the f-stop that falls in the middle of the two readings you obtained, and use that as the exposure setting. For example, if the highlight area metered f/16 and the shadow metered f/4, you would use f/8 as the exposure setting.

If the distance between the highlight and shadow detail areas of the image is beyond seven stops for film or nine stops for digital, the system will not work well. Note that when the distance is an even number of stops (e.g., f/16 to

TONAL PLACEMENT METERING

IS THE PREFERRED METHOD

FOR SETTING EXPOSURE FOR

BLACK-LINE IMAGES.

f/5.6) the average value will be a half stop. In this case, you should select the value below the midpoint for film and the aperture setting above the midpoint for digital work.

Photograph by Glenn Rand.

STUDIO EXAMPLES AND APPLICATIONS

The way glass is approached is a matter of choosing what is important in the glass. As mentioned in chapter 3, reflective effects on the outer surfaces provide visual clues as to the volume of the glass, and passing the light through

The light envelope for this image included a softbox placed vertically on the left side, a fill card to the front right side of the camera, and a fill above and behind to produce the rim light on the glass. Photograph by Bob Vigelleti and Glenn Rand.

Facing page—This image was created as a demonstration in a beginning lighting class at Lansing Community College taught by Dan Trometter. The streaked light in the background was made with a gelled light across the gray seamless background. Because no light was reflected on the sides of either the shaker or the glass, both have a basic black-line look. An overhead left-side fill light reflecting on the rear inside surface of the glass is brighter than the light on the background or the shaker, and it creates a soft reflection and a rim light.

the glass gives a good indication of contours and emphasizes colors or densities of the glass or transparent/translucent materials. For the most part, we want to use both the transmission of light through the glass (black line) and reflections on the surfaces of the glass (white line) approaches. However, one type of lighting will be dominant.

The key to creating a successful photograph of glass is defining the structure of the material being photographed and choosing a lighting style that will accent the structure as desired. This analysis determines how the light envelope will be constructed and how the lighting tools will be used. Though a light envelope can be constructed anywhere, it is easier to control the light within a studio.

The studio for glass lighting is like a matryoshka (Russian nesting doll). The studio is inside a building that allows for control of light, and the light envelope for the glass is inside the studio. The lighting envelope may also have further controls within its space. The best studio is dark with no external light entering or light-toned surfaces, since light can reflect from any surface and this light can interact with the glass. Remember, it is easier to place or construct light surfaces in a dark studio than to darken areas in a light studio.

Within the studio, light coming from one source or another has basically the same ability to light the glass. The major difference between the two major artificial lighting sources, continuous and electronic flash, are the ability to see the light before exposure and its duration. Even with modeling lights, the effect of the light envelope on the glass will not be seen before exposure. Electronic flash has the ability to stop action and is cooler to use. For learning purposes, continuous lights are easier.

With these things in mind, the following case studies show how light envelopes are created for specific subjects.

MAKING A SIMPLE IMAGE

We wanted to see the color of the wine so a black-line technique was chosen. Since the form of the glass was unimportant, no other lighting concepts were considered. If we had chosen milk for the "pour," we would have wanted to use a white-line technique to front light and keep the milk white.

For motion-stopping purposes, electronic flash was required for this photograph. The lower the power of the flash, the faster the flash. With lower power in the flash, a larger aperture will be required; thus, depth of field will be limited. The lighting for this photograph was very simple, with only one light. Because the light in the background was strong enough, few if any reflections will be seen in the glass.

In many situations this image would be done with a shutter/flash synchronization system using an infrared beam or acoustic timing circuit. However, the image shown here was produced without the aid of this type of trigger.

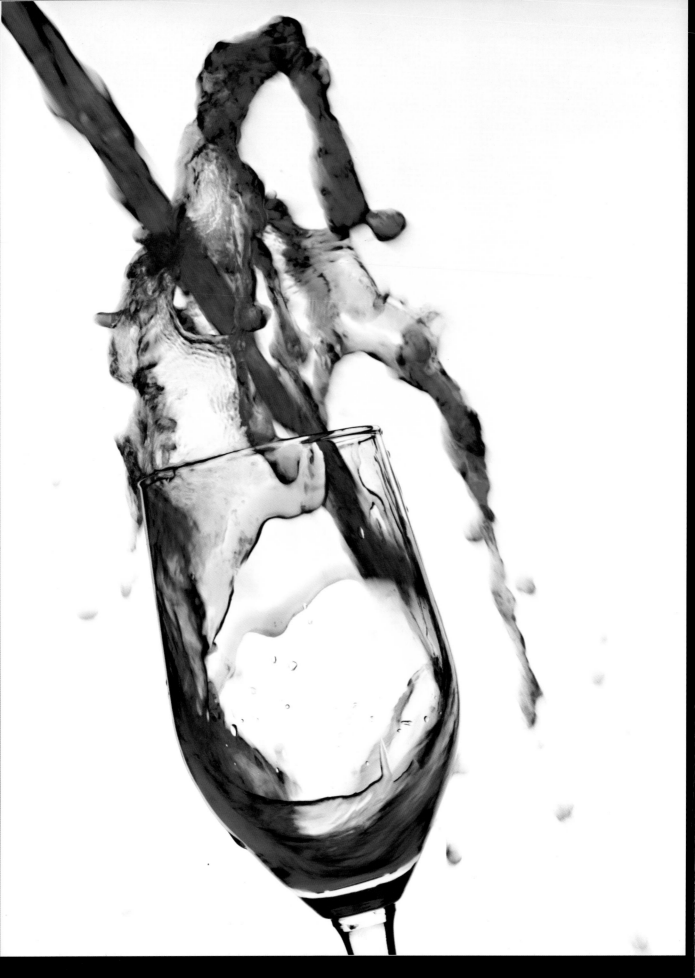

Facing page—The color of the wine was an important photographic element, so a black-line approach was required. Though the image was captured vertically, the camera was tilted slightly. The studio was totally dark with the shutter opened and flash discharged when the pouring started. Photograph by Glenn Rand. **Diagrams—(top left)** The camera was positioned with the lens parallel to the glass, and a diffusion panel was placed behind the glass. Since the liquid would be splashing, the panel was placed at a safe distance. The glass was secured to a tray so it would remain steady when the liquid spashed against the inside of the glass. **(top right)** A black-line setup was established with a diffuser used instead a softbox. This allowed the backlight to be patterned rather than having an even light behind the glass. The light was angled at the diffuser so that the light was not pointed directly at the camera. The flash unit was set at its lowest power. Measuring the light of the diffuser and opening up $2^1/_2$ stops established the exposure. Since the speed of the flash stops the action and the intensity establishes the aperture, the shutter speed could be slower than normal. This allowed for a small amount of blur in the pour, giving a better feeling of motion. **(bottom left)** A funnel was positioned and anchored, aligning the pour to impact the middle of the glass's inner surface. The funnel allowed a smooth movement of the liquid; when pouring from a bottle, the air in the bottle will cause spurts. If a bottle is to be used for the appearance of the neck, there must be an opening in the bottle to allow air to enter and replace the liquid exiting the bottle during the pour. The pour is directed so that the splash will move slightly away from the diffuser so that the diffuser stays clean. The height and inclination of the funnel determine the amount of splash and the way it will swirl in the glass. **(bottom right)** At this point the lights are turned off, including any modeling light in the flash unit. A predetermined quantity of wine is poured into the funnel. The amount of wine determines the length of the pour that will be seen in the photograph. Based on the sound of the pouring, the cable release is depressed, setting off the flash. Because of the natural reaction time between hearing, action, and the time required by the equipment, the splash will have formed at the time of the flash's discharge. With a digital camera, depending on the sequencing of the sensor, a time exposure may be required with a separate firing of the flash to accomplish the photograph.

ENGINEERING LIGHTING

This photograph is an example of the "engineering" that is needed to make some images of glass. Though simple in terms of the lighting environment, the set needed to be constructed to allow the light to interact with the glass. A bag of candy was used as a background for the glass art.

We wanted to produce an image with a dreamy feel. The lighting for this photograph had two distinct requirements. To show the color of the glass, a black-line concept was required. Therefore, the light source for the candy had to be a white translucent shelf in the bag with the ability to get light to the

To design this photograph a bag was used with real and glass candies. The glass candies were transparent and opaque. This dictated that both white-line and black-line lighting be used. The soft, dreamy look was created with a second exposure using a diffusing filter. Photograph by Glenn Rand.

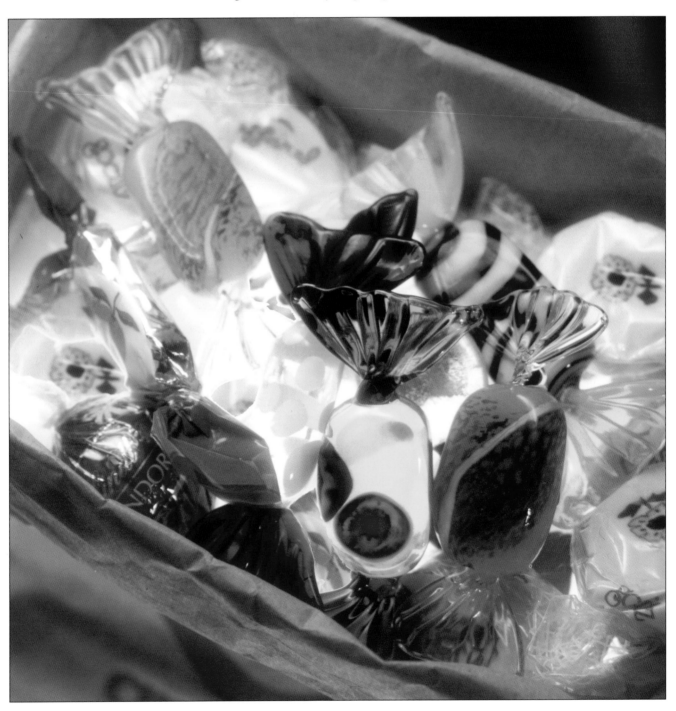

Diagrams—(top left) The brown bag was placed on a white Plexiglas shelf with a light below. The cutaway shows that the bottom of the bag was removed. **(top right)** The insides of the bag were reinforced to support a small piece of Plexiglas. **(bottom left)** The candy and glass candy were placed on the Plexiglas shelf in such a way as to allow light to come through to the glass. The arrangement of the glass candy was chosen, then the wrapped candies were layered into the set to fill blank spots or to support the glass candy to give it the desired view in the photograph. **(bottom right)** The exposure was calculated for the needs of the black-line portion of the photograph and set to meet two-thirds of the exposure. With this in mind, a white card was positioned above the set and separately illuminated with a second spotlight. To avoid lens flare, it was critical that none of the light coming from this second spotlight was allowed to reach the camera's lens. After a first exposure, a light diffusion filter (a piece of clear but uneven glass) was moved under the camera and a second exposure was made equal to one-third of the calculated exposure.

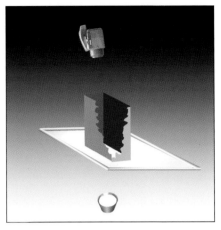

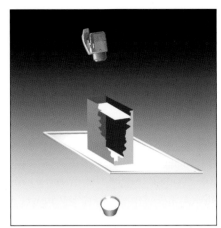

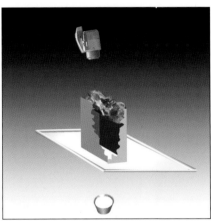

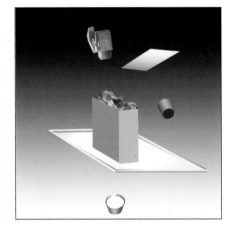

bottom of the shelf. However, since there will be real candy and details in the densely colored glass in the image, light was required to illuminate the camera side of the set. To highlight the detail and edges of the glass candy, a diffuse source was used to create a white-line effect.

Continuous lighting was used because the photographic concept required a softening filter. Though a diffusion filter could have been used over the lens, it was used for a second exposure. This created soft halos on the brighter areas of the image. Though soft halos were formed on the highlights, the darker areas were less affected by the diffuser since there was less intensity to "smear" with the diffusing filter.

A spot meter reading was taken through one of the pieces of glass candy. This established the tone of that piece of candy in the midtones. The light from the fill was adjusted by moving the light in relation to the card until an incident meter reading at the surface of the candy matched the exposure determined for the light transmitted by the glass candy.

Finally, an equivalent (long) exposure was chosen to allow in-camera softening. Using a piece of glass that was moved between the set and camera during a second exposure created this softening. Moving the glass between the camera and set created a small amount of lens flare, producing halos on the brightest areas of the image. Softening was applied to crisp details captured when the glass was not in motion.

TRANSLUCENT OBJECTS

In order to show the translucent quality of an object, we must use black-line lighting. That means that the light used to show the translucent object (or area) needs to be transmitted through the object and toward the camera. Due to the makeup of translucent materials, light entering the object is diffused as it is transmitted. This spreads the light as it comes out of the material. In the example shown here, the base of the flower stand is made of translucent acrylic with a light coloration.

With a diffuse subject (the rose), there will also need to be light coming from the front half of the light envelope. This light was balanced to ensure that the amount of light transmitting through the translucent base would be more powerful than any light hitting the side surface of the acrylic stand.

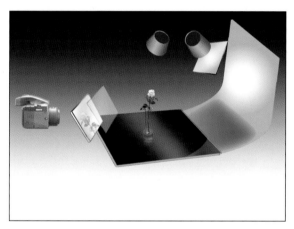

Diagram—The background was lit with a spotlight with a blue gel. The light from the background reflected directly behind the subject off of the black Plexiglas. Last, fill was added to the rose with a mirror. A second spotlight was used to light the rose and to reflect back from the mirror. **Right**—Our black-line lighting effect required that the area behind the acrylic base had to be the most intense. Therefore, black Plexiglas was used as a base and reflected the most intense pattern of the light onto the surface directly behind the subject. The resulting light shape on the Plexiglas had a light center that fell off to a blue color. Photograph by Glenn Rand.

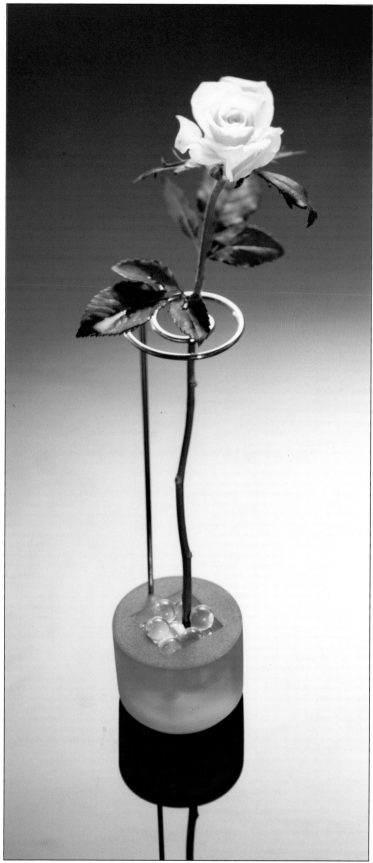

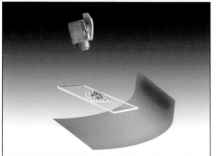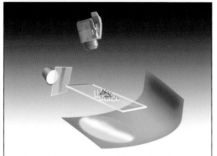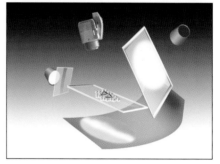

Top—Here, transparent objects supported the main subject of the image. Photograph by Glenn Rand. **Diagrams**—**(left)** Acrylic balls of various sizes were supported on a piece of glass with the silver earrings placed on top of the balls. Beneath the glass was gray paper. **(center)** Blue and magenta gels were placed in front of a small spotlight aimed onto the gray paper under the glass, acrylic balls, and earrings. This created streaks of colored light on a gray surface. The balls act as lenses, transmitting the color from below to the camera. With this setup, the color coming through the balls will be less intense, giving rich colors in the balls that will not overwhelm the lighting on the top surfaces. **(right)** Finally, a diffused light was used above to illuminate and reflect from the earrings. The light above was controlled to have the reflection in the brightest part of the silver to be exposed as white, allowing falloff of tones in the earrings.

SUPPORTING OTHER SUBJECTS

Glass materials are not always the subjects. Often, transparent or translucent materials serve as a background for, or to support, the main subject. In such cases, these materials need to be handled effectively or they can destroy the image. Of course, transparent or translucent materials can also be used to enhance the appearance of the subject.

The earrings we needed to photograph were patterned with circles, and that feature was considered as a design element for the photograph. Because

the circles on the jewelry are shiny, certain backgrounds would not help the image. The concept of supporting the earrings using marbles was considered, but as the marbles had opaque interiors and intricate coloration, they would have distracted from the earrings. Clear acrylic balls were chosen instead. To add color to the image the transmissive qualities of the acrylic balls was employed.

STUDIO APPROACH OUT OF THE STUDIO

Some photographic concepts require working with glass in a natural setting. The following image was made at Crystal River to take advantage of the natural setting and illustrate a product from a local glass workshop. The same thought pattern went into selecting angle of view and subject control as would be done in the studio.

Left—Tim Reed took a glass trout into nature to make this image. The glass jumping trout was anchored to the river bottom. The angle of the shot was chosen to have the sky reflect in the water to create a better background for the glass and to produce a black-line effect for the color in the glass. A focusing mirror was used from the near bank to put specular light into the back of the glass trout, bringing out the color and glitter of the glass. Glass used for this photograph was by Mary Marshall of Crystal Glass Studio in Carbondale, CO. **Above**— This view of the setting shows an assistant aiming a mirror into the back of the glass fish to create sparkles and better color in the glass.

GLASS THAT IS OR IS NOT THERE

It is often the case that we want glass in a scene to disappear in the image. In other instances, the glass is an important image element and must be visible. Whether this is a scene we come across in the world around us or is an illustration in the studio, understanding the lighting conditions and the reflective aspects of glass gives us the ability to minimize or show the appearance of the glass.

WINDOWS

Perhaps the easiest glass example to consider photographing is windows. They are common in our visual world. We need to think about photographing from both sides of the windows—the inside and the outside.

Using the same logic that makes white-line and black-line happen, we can approach the way windows will look. Whether creating a black-line or white-line image in the studio or photographing the world around us, it is the relationship between the reflection and the background or tone of the glass that affects the look of the photograph. However, with windows we have an added complexity: we must consider the inner space behind the window or what is seen through the window.

WE NEED TO THINK ABOUT PHOTOGRAPHING FROM BOTH SIDES OF THE WINDOWS.

When photographing windows, you must first choose the camera angle required for the desired design of the image. Next, you can consider the three ways the window glass functions within the image: First is what is seen through the window. Next is what is reflected in the window. Last is the interplay between what is seen through the window and what is reflected in the window.

Of these three concerns, the first to be considered is the view through the window, as the tones seen through the window will be key in determining how the reflections will appear. If the area is bright, then reflections will be reduced; if the area is dark, the reflections will be more prominent. When the reflection is weak (e.g., from a dark reflecting object), it will not be seen when the area behind the window is bright. It will appear faint, however, if the area

Facing page—This photograph was created to be as flat as possible. This gives the strongly rectangular form. Since the light is coming across the street from this window, the building on the other side of the street has its front in shadow, lessening the reflection on the window and allowing the viewer to see into the interior space. With this approach, the view through the window is apparent as it fades to black deep inside the building. Photograph by Glenn Rand. **Right**—Photograph by Michael Rand.

visible through the window is dark. If the area visible through the glass is important, the metering of that area must be considered for the overall exposure.

We must also consider what will reflect in/on the window. If it is important to see through the window, then avoid bright lights or highly illuminated objects (particularly light-colored materials), which will create reflections in the window. We are familiar with photographers who have taken snapshots in front of a window using their on-camera flash and produce an image with a bright flash reflection obliterating the view through the window. We've also

Facing Page—The multilayer of the window construction with double glass creates complex supportive reflections. Though the reflection of the sky obscures part of the detail in the leaded glass behind the overglazing, it allows the repetitive reflections of the metal grating to be seen. The reflections from the buildings in the overglazing allow and accent the rectangular pattern of the leading. Photograph by Glenn Rand.

Right—The existing conditions and the layering of window reflections made this photograph possible. Because the building across the street was painted black, much of its reflection was reduced. With the light coming straight down, there was no glare on the window of the frame shop. The camera was positioned so that it reflected back to me in the center of the small frame, and in this way, that is where my eyes would appear in the image. Photograph by Glenn Rand.

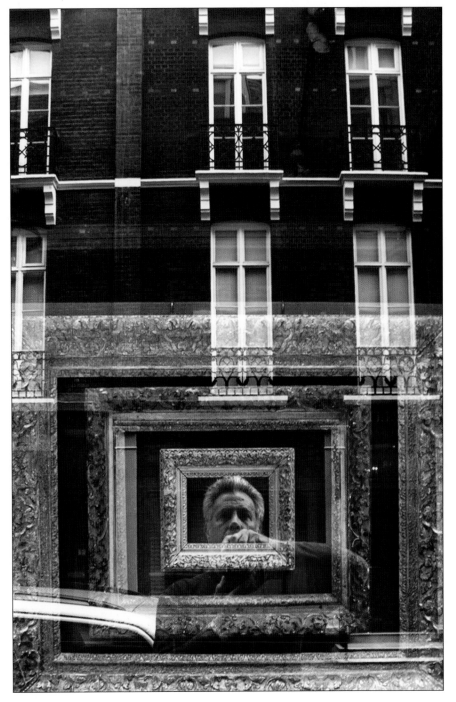

seen images in which the photographer's reflection is visible in a window because they were in the bright sun and wearing light-colored clothes.

Though unwanted reflections can detract from an image, including the right reflection in the image can enhance the photograph. It is often helpful in building an image concept to have the reflection in/on a window to create an accent in the window. Since windows are rectangular and cityscapes are made up of vertical and horizontal lines, an urban reflection can be interesting. Organic, natural objects and landscapes reflected in a window can create a nice contrast to the rectangular structure common in windows. Remember

This photo taken on a train platform would have reflections on the window if taken from a standing position, but from a lower position, the glass of the window reflects the underside of the platform's roof, even though the lower part of the window is in bright sunlight. This allows the viewer to see through the window, to see the lights on the inside of the snack shop, and to see through the window on the other side of the building. Photograph by Glenn Rand.

that the sky, normally bright, will actually be reflected in a window when photographing at an upward angle.

The last, and often most interesting, consideration is the layering of details that are visible in the reflections and through the window. In such a scenario, the exposure is important. Also the contrast difference between the reflections and other image elements, both in front of and visible through the window, need to be considered. As will be discussed later, the contrast between the reflections and other elements can be manipulated through the use of a polarizing filter.

In all three considerations for making the most out of photographing windows, the camera angle is critical. It is important to note that the layered image may not photograph as we see it. This is because our eyes are moving and our perceptual system holds constant our knowledge of what we have just seen. Often the image will be improved if the camera is moved and angled to change the position of the reflections on the glass.

Normally, when photographing through a window from the inside to the outside, the reflections on the window's glass tend to be unseen. Because the light on the inside of the space tends to be darker than the light outside the window, clean windows tend to be unseen. However, this is not always the case.

Once again, the angle of the camera to the window and the tone distribution outside become important. If the subject outside is made up of darker tones, then how dark the potential reflective portions of the inside space are becomes critical. If you photograph at an angle to the window, then the area of the inside space that can reflect is part of the light envelope. Aiding in minimizing the reflections on the window is the interaction of light with the glazing of the window. The most commonly used window glass transmits over 96 percent of the light. This means that the potentials for reflections on the inside of windows will be easier to reduce when the potential reflection is weak.

When photographing through a window from the inside to the outside, the light indoors is typically less bright than the light outside, causing clean windows to be unseen. Photograph by Glenn Rand.

Aerial Photography. Unless specifically designed with the camera mounted through the fuselage of an airplane, aerial photographs are typically taken through the airplane's multilayered, pressurized windows (though some photographers photograph from low-flying planes through open windows). Unless you are hiring a specialized aircraft, you will be photographing through fixed windows. But regardless of the type of window you will want to use a soft (rubber) lens hood so that the camera can be in contact with, or close as is reasonable, to the window to block unwanted reflections and reduce flare.

Facing page—The window in the background has material attached to the inside surface. This makes the window function as a mirror even though the red material is transparent. Photograph by Glenn Rand. **Above**—Lake Powell from 36,000 feet. The camera was positioned so that sunlight coming through the window did not hit the camera's lens, and the area that might have reflected into the window from the camera's position was covered with black material. Photograph by Glenn Rand.

POLARIZED LIGHT

Light travels in waves. When light reflects from a nonmetallic surface, the light waves align with the surface. This means that the reflection from glass can be controlled through the use of filtration. A polarizing filter will control the way light reflecting from the surface appears in the photograph.

Polarizing filters have a micro-metallic structure that allows light waves that are parallel to the structure of the filter to pass through while blocking other wave alignments. This means that a reflection in a window can be emphasized or de-emphasized when a polarizing filter is used.

Though polarizing filters are more commonly used in the found environment, there is also an opportunity to use polarizing filters on lights and on the camera when working in the studio. When the illumination from the light source is filtered *and* the on-camera filter is used, reflections from the glass are further reduced.

Though polarizing filters are generally used to eliminate reflections, it should be noted that they also reduce the overall illumination available for exposure and can change the contrast of the scene. When the filter is aligned with the reflection, a higher proportion of the light from the reflection is transmitted than is transmitted from the surrounding scene. This increases the image's contrastiness and can help obscure the image through the glass if there is any reflection on the glass.

If light is polarized and passed through plastic with a polarized filter on the camera, the resulting image will show defects and stress in the plastic. The polarity of the light is changed by the defects or stress altering the color recorded by the camera.

CASE STUDY:

UNSEEN GLASS IN THE STUDIO

Eyeglasses. When working in the studio, opportunities to photograph portrait subjects wearing eyeglasses can present unique challenges. In most cases, when the subject wishes to wear their eyeglasses, reflections from the

Below—With the light source from the side, no light illuminated the lenses of the subject's glasses and no reflections appeared. Photograph by Christine Trice. **Facing page**—For this self-portrait, Tim Meyer used a flash unit with an umbrella close to perpendicular to the camera axis, creating the large incident angle with his glasses. This reduced the reflection on his glasses. A reflector was used opposite the umbrella for fill.

lenses must be controlled. We will typically want to have the glass appear clear with the eyes unaffected by any reflection from the glasses, though there are a few instances when a "blush" of light might be desired on the subject's eyeglasses.

The more shape the lenses of the glasses have on their outer surface, the more likely reflections will be present. This is particularly true when a broad light is used from any position in front of the subject.

To gauge the reflections, the subject's glasses must be viewed through the camera. Even standing beside or behind the camera may not make apparent the actual reflection.

Posing and lighting can be used to reduce or eliminate the glare on the subject's eyeglasses to produce the best-possible portrait. A common means to reducing reflections on the glasses is to have the subject pose using a head tilt that produces a large angle to the light, as this will reduce the likelihood of light reflecting off the glasses. This might be as small as a slight tilt down or away from the light. Also note that the quality of the light will affect the reflections. Specular, small, lights will create small reflections on the spectacles, and a broad, diffuse light creates potentially larger reflections.

The positioning of the lights also has a bearing on potential reflections on the subject's glasses. The closer the light is to the camera's position, the more likely it is that there will be reflections in the eyeglasses. Also, when the light arrives at a small angle, the glasses can focus a light pattern on the subject's face. Thus, higher light positions that are off camera axis reduce reflections and light patterning on the face.

There are instances where a light indication of the glass, a "blush," is visible on the glasses. In this case, two issues will affect the success of the image. Since seeing the eyes is important in a portrait, controlling the amount of blush so that it does not obscure the eyes is a major concern.

Though the glasses reflect very little light, improperly aligned lights that directly create the light on the glasses can cause problems. In situations where a blush is desired, it is better to use an individual fill card or flat that has patterned light illuminating it, and then light the rest of the portrait with a lighting pattern that causes no reflections on the glasses.

As a corollary to this discussion is what happens when photographing a wedding reception: because we move about the guests with a flash attached to the camera, the position of the light stays in close relation to the camera axis. To minimize unwanted reflections from guests' glasses, any flash should be mounted as far off the camera axis as possible. Working with the wedding guests to avoid head positions that promote flash reflections in their glasses (particularly looking up toward the camera) will ensure the best outcome.

Products. Sometimes the best thing about glass is that it is not there. Properly placed glass can be used as a non-object in photograph; it can change the way the image is used or modify its look. Particularly in the studio, it can also

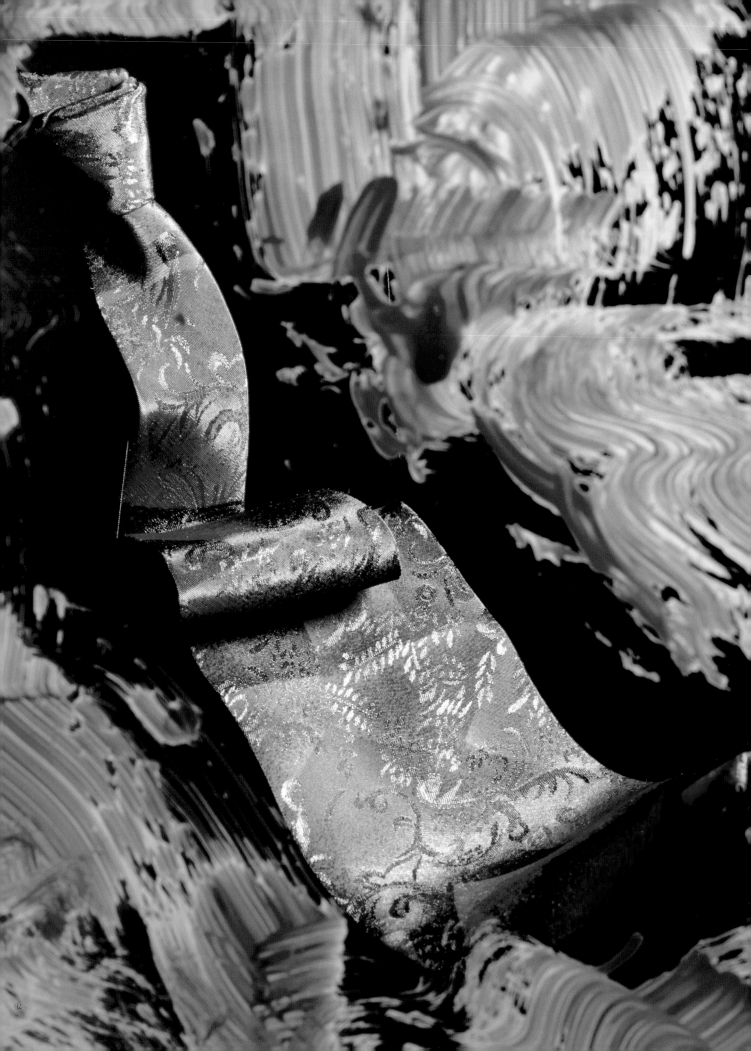

be used to support or reflect things into the image without being obvious. This is why it is used in magic tricks and special effect photography.

Many photographers use a polarizing filter to render glass invisible in a photograph. Though this may work, it is more effective to use other controls. Understanding how to light glass is essential to ensuring that it is unseen in an image.

Clean glass will not be recorded by film or digital sensors when reflections are absent. Therefore, careful lighting can make it appear as desired or not be seen at all. When glass reflects black it will not be seen and will not affect the exposure. However, it is important that the reflection on the glass is of a black

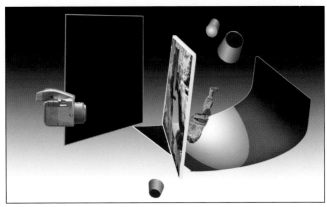

Facing page—Michelle Daily, a student in an advanced lighting class, created this image of a floating tie with brush strokes in the foreground. **Diagrams**—**(top left)** The set was a black background that was far enough from the tie that no light on the tie would spill onto any area in the picture. The tie was suspended using unwaxed black thread, which reflected no light and disappeared into the background. A single spotlight from the front-right quarter was used as the main light. The exposure was defined with an incident meter reading at the tie. In most glass and metal photography, it is helpful to have the camera on a tripod, but in this case it was imperative. **(top right)** A clean, unscratched piece of glass was positioned near the tie and angled so that the right side was closer to the camera. A large black card was placed on the left side of the camera so that the borders of the card were not visible through the camera. It was also important that no light shone on the black card. **(bottom left)** Gesso (a white plaster and glue compound used to prime canvases for painting) was brushed onto the glass to create a pattern that would allow the tie to be seen clearly. **(bottom right)** Finally, small spotlights were shone on the painted glass. The spotlight on the front side was gelled with light cyan. Another spotlight, placed at the camera-left rear, cast a magenta light on the back of the painted glass. Both spotlights were controlled so that no direct light fell on the tie. A small amount of the light reflected from the magenta light into the tie, and some of the mixed intensities became a diffuser source for the tie. Because the angles of incidence on the glass of the small spotlights were so large, no light was reflected onto the black card, and the light coming from the front (cyan) spotlight did not reach the tie. Because of the texture of the gesso, the magenta light coming from the rear would mix in some areas with the cyan to create a bluish cast. Depending on the thickness of the gesso, the two colors could be strong enough to create white. Where the rear light dominated, a magenta cast was created. Using a spot meter and moving the spotlights to a position that gave the desired separation in tone from the established exposure allowed for the lightness of the colored light.

material (a flag). If the reflection is only of an empty space, light-reflecting material can enter the reflection and show up in the photo.

Polarizing filters are often used when photographing glass. With this filter in place, you must use TTL metering or take into consideration the exposure compensation required with its use. You can find additional information about polarization in the appendix, located at the back of this book.

Left—With the darkness inside the building, there are no reflections on the glass in this architectural detail. Photograph by Glenn Rand. **Facing page**—Ralph Masullo used only a softbox to light the clock face shown in this image. The reflection on the right side of the crown glass gives a sense of shape without obscuring the face. Note the projection through the window behind the clock, which allows for a view of the building on the other side of the street.

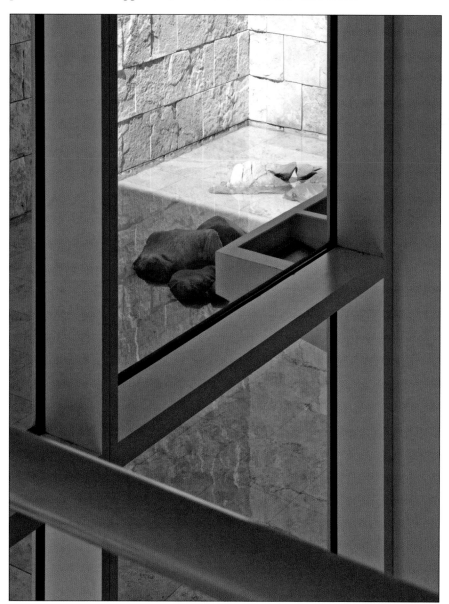

CHAPTER SEVEN

PHOTOGRAPHING GLASS FOR PHOTOSHOP EDITING

Choosing to work in Photoshop does not eliminate the need to know how to light glass. Unless you are an expert Photoshop airbrush artist, adding white lines or creating the glow of a backlit liquid will be difficult if not impossible. However, when you understand how light interacts with various glass surfaces or transparent/translucent materials, you can use Photoshop's layers, selection tools, and opacity settings to digitally enhance your lighting effects. Note that though this process can be done with scanned film or transparencies, it is easier to start with digital image files.

Since this book is not about Photoshop, we will not go into the finer points of manipulating these controls and choices.

RETOUCHING TRANSPARENT AND TRANSLUCENT SUBJECTS

The simplest application considered for Photoshop in lighting transparent and translucent materials is the use of retouching. Careful construction of the lighting allows for easier post-capture correction. Though there may be some unwanted light effects, if the subject is carefully lit, retouching will be easier.

There are many tools that can be used to retouch glass. Most common are the brush tools and the cloning tools. The brush tools are used to add a pre-determined color or tone in one of three ways. The pencil tool allows the color to be placed in the image at specific locations at a predetermined size. The pencil tool is a constrained shape from one pixel to very large circles.

There are two other brush options: the first is used to replace color, and the the second acts as a color overlaying tool (like a paintbrush) or as an airbrush tool. The difference is that the airbrush tool allows for more control in the application. In other words, the density is built up by repeatedly applying the tool. All brush tools offer a wide variety of shapes and hardness of the edge and include customized shapes and textures. When using brushes and pencil tools, color can be applied with differing opacities, allowing the photographer to control the degree to which the added color or tone covers the underlying photograph.

CHOOSING TO WORK IN PHOTOSHOP DOES NOT ELIMINATE THE NEED TO KNOW HOW TO LIGHT GLASS.

This simple image was created with Photoshop editing considered from the outset. The translucent ball with a red back and blue front was lit with a small light with a long black paper snoot under the ball. Because the ball is translucent, the light was diffused through the ball, giving it a glowing look. Photoshop was used to remove any vestige of the snoot and increase the light's effect on the ball. Photograph by Glenn Rand.

THE CLONE TOOL ALLOWS AN

AREA TO BE REPLACED WITH

ANY OTHER PIXEL ARRAY

FROM PART OF THE IMAGE.

The clone tool allows an area to be replaced with any other pixel array from part of the image (i.e., it's like copying one part of the image and placing it over another). The size of the clone tool, as well as its hardness and opactiy, can be manipulated to achieve the desired affects. Unlike the brush and pencil tools, the clone tool is not constrained to a specific tone, color, or pattern. It can be used to add variable tonal areas, tonal patterns, and image parts.

Simple retouching was used to finesse the image shown here. Small areas that showed an unwanted light pattern, or the lighting tool itself, were removed by covering them with tone from the background (black) or reestablishing color or tone on the wrench. The clone tool was used with a soft edge. A small pixel diameter was used, and the sampled pixels were near the area to be corrected. To avoid creating an unwanted pattern, the cloning distance was changed slightly as the process went on.

PHOTOSHOP'S LAYERS

Photoshop is often used to composite images. This allows photographers to light a transparent or translucent material and later combine the image with another to give the subject a new background, new context, or new look. In order to make the scene look believable, however, the transparent or translucent material must be lit in a way that suits the "new" set or background.

Layer compositing of images can be thought of as a computer-based method for multiple exposure. The photographer determines how each part of the image will appear in the new picture and then places the parts of the new image in specific layers that are stacked in Photoshop. As successive layers are added to the stack, the higher on the stack, the more they obscure of layers below. Opacity control can be used to allow parts of the lower layers to

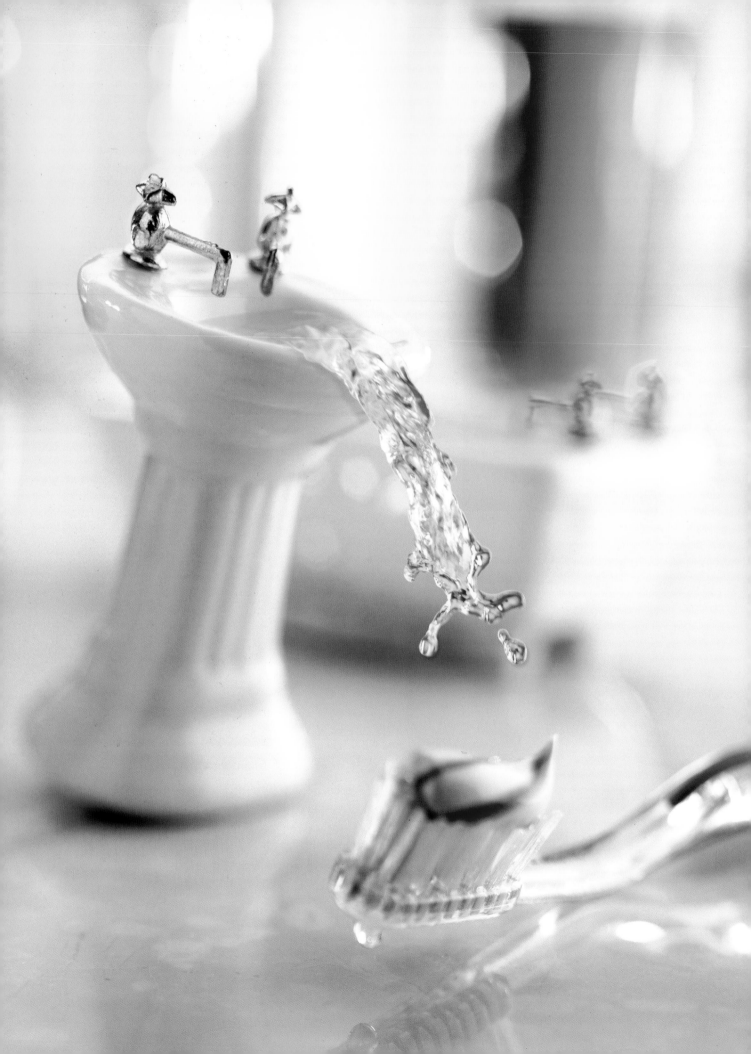

Facing page—Ralph Masullo used two separate exposures to create this composite image. The first image was a "dry" photo of the miniature sink in its set. He used a separate exposure using an infrared trigger to capture the splash. The two images were then composited in Photoshop.

show through higher stacked image parts. For glass lighting, layers can be added to lighten or darken, change the saturation, hue or luminosity, etc.

Still life/tabletop and architectural subjects are good candidates for this technique, because the size, position, etc., of the subject and image elements should remain constant from one frame to the next. To ensure the best results, it is important that the camera be immobilized and that the focal length and focus are kept constant (i.e., be sure to turn the auto-focus off) from frame to frame. A change in the camera position, focal length, or focus can result in the image elements being recorded smaller or larger from one image to the next, which, when compositing, can make the resulting image appear manipulated.

When lighting transparent and translucent subjects, reflection from the subject and the relationship of the reflections to the background are critical. The lighting effects shown in the image of the calendar (see pages 80–83) were captured in-camera. It is difficult to create lighting effects in Photoshop, and when a lighting effect is applied post-capture, it tends to look fake.

When using these methods, there are two related but distinct stages of the image creation. The first part is lighting the various portions of the subject. Unlike what has been shown to this point in this book, we do not need to contemplate how to achieve all lighting effects at one moment, but we need to choose what effects we want to see and then separate them into distinct parts of the lighting. When we choose the lighting we will use we need to think ahead and contemplate how various portions will be selected and put together.

The second part of the process will be to put the portions of the lighting together through selection, layering, and global changes available through Photoshop. Because we are using selections in the production of the image, we do not need to hide all the lighting elements. We can bring reflectors, flags, and lighting control elements close to the subject for maximum effect and remove them digitally in post-capture.

For the purposes of this chapter, we will make an image of an acrylic calendar. This was chosen because the reflective angles are not complex, and the calendar has parts that need to show their clarity as well as showing information through the clear surfaces. At the same time, we need to show the dimensionality of the two pieces.

The final photograph (page 83) is a flattened version of a file comprised of multiple image layers, each made with a specific lighting objective. Though these effects would be very difficult to set up and capture in-camera in a single image, Photoshop makes the task much simpler.

The lighting objective was to make the image look clean and uncluttered. With the calendar's flat surfaces, the reflections are very controllable, but the frontal view means that reflections of objects from the camera side may appear on the surface.

When we look at the sequence of five images that were made we see how the lighting functions. In the first image, the background and overall form of the final composite were captured. Since this image is as much for positioning as for the background, we do not need to consider the lighting of the acrylic. In effect, we are using a black-line concept to light the second image, capturing the orange color. In this image, we used lighting and exposure to ensure that the orange color was more intense than any reflection on the front surface and internal light streaks created by refracted light entering the front of the calendar. This lighting and exposure provides a clear surface to view the orange surface as well as the numbers and letters.

The first real lighting effect is seen in the third image, with the creation of a white-line effect on the top of the calendar. We used this to establish the flat top surfaces. By using a separate image for these reflections we are able to control the intensity and pattern of the reflection without creating reflections or refractions elsewhere in the picture.

We use the white-line approach to capture the numbers. By using black material behind the numbered area we ensure that the reflections from the white numbers are clearly visible. We also use white-line lighting to create light streaks on the front-facing surfaces. Here we only need to ensure that the illumination of the light reflecting will be brighter than the orange background and the backdrop that is seen through the clear areas of the calendar.

Top left—The setup for the first image, which was created for positioning and to set the background's tone. **Top right**—Because of the overall lighting of the set, the calendar shows internal refractions and reflections (the light and dark areas in the front piece). The back portion of the calendar is not seen because no direct reflections appear on its surface. With light on the background, the numbers do not show well through the clear circles. **Bottom left**—The setup for the second image, which was made with a light from the camera side and at a slight downward angle to illuminate the orange surface of the calendar. The downward angle of the lighting reflected the slightly diffuse light source onto the paper material in front of the calendar. An overexposure was made to eliminate tonal inconsistencies caused by any refraction or internal reflections. **Bottom right**—The result of the second image is the even tone of the orange back of the calendar, with internal white lines clear and crisp. Photographs by Glenn Rand.

Top left—Though in the second image, the calendar had a reflection on the top surfaces, it was uncontrolled. Therefore, a third image was made with a white reflector placed directly behind the calendar. This was lit to create the desired reflection on the top surfaces. **Top right**—The reflection from the top surfaces in this image will be used. **Center left**—The fourth image was produced to capture the white numbers on the rear acrylic piece of the calendar. To make the numbers show, a black card was placed behind the numbered area. Lighting was from the front and to the side to directly illuminate the numbers and letters within the calendar to illuminate the back. This ensured that the numbers and letters could be photographed. **Center right**—The numbered circles and the letters will be used from this image. **Bottom left**—The final image in the set will be used to put a light streak across the face of the calendar. Placing a white reflector in front of the calendar and illuminating it with a pattern of light from above accomplished this. Because the camera is pointed downward and the light pattern is in front, the reflection appears on all front-facing surfaces. **Bottom right**—From this image, only the light streaks will be used. They give three-dimensionality to the finished image. Photographs by Glenn Rand.

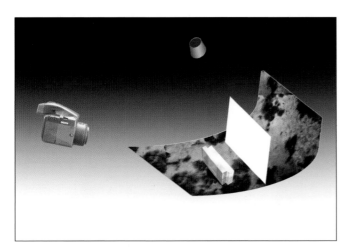

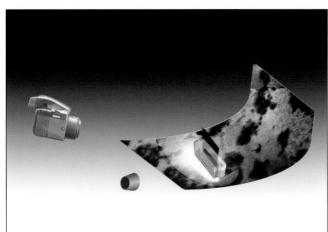

PUTTING THE PIECES TOGETHER

Because we created the images from a single position without a change in focus or magnification, and for specific purpose of compositing them to create a single final photo, the images go together quite easily.

Top left—This screen grab shows the image structure without the light effects. This image will be the background, so the light level was adjusted using Curves to achieve the desired look and tone. **Top right**—The second image was copied as a new layer. To accomplish this, the colored area of the calendar was selected over the base. The Lighten blending mode was used. **Center left**—The logo was lightened and the day notations were darkened. **Center right**—Light reflecting from the top of the calendar was taken from the third image and layered into the composite. A slight Gaussian blur was applied to smooth the highlight reflection. **Bottom left**—To prepare this layer, the orange was first selected in the image and deleted. This left the black circles with the white numbers. The contrast of the black circles was then increased; this enhanced the visibility of the numbers. **Bottom right**—Last, the streak for the face of the calendar was copied to the composite. Even though the highlight was selected, it was copied into the composite as a Lighten layer and adjusted to 83% opacity. Finally, the image was saved as a layered TIFF file, then cropped, flattened, and saved again under a different name.

The final image of the calendar. Photograph by Glenn Rand.

Though the compositing can be done in 16 bits per channel (48-bit color) for most applications and operations, the 8 bits per channel (24-bit color) bit depth setting reduces the file size and allows more effects within Photoshop. As an example, a 10 MP camera will create a 60 MB file at the 16 bit setting when interpolated. This means that every layer used in Photoshop will be 60 MB without masks or paths used. In this example, five layers will be used before flattening, making a working file of 300 MB if working at a 16 bit setting. When the images are created using the 8 bits per channel setting, the five layers will take up only 150 MB. The smaller file sizes will be easier to manipulate and composite.

Though you will want to keep your original images at the highest bit depth and in RAW format (if that is the way they were captured), you will need to work in an interpolated format such as PSD, TIFF, JPEG, etc. These will be your working files. It is best to save these interpolated files with a different name.

Facing page—This image was created using three image lighting layers and a gradient. The ice cubes were lit with a moving light source behind the glass creating black-line lighting for the glass, cubes, and liquid. This was layered over the base exposure, and the Lighten blending mode was selected. The white-line effect was created with another moving light, and once again layered over the composite with the Lighten blending mode selected. All layers were prepared with softened edges. The gradient was added between the background and first lighting layer to create the contrast needed to see the rim light. Photograph by Glenn Rand. **Above**—To create this image, we composited multiple photos to get the desired glass lighting. We used selective erasing in the foreground and gradient tonal light to darken the background. Photograph by Glenn Rand.

In this example, we start by opening our positioning image. Because all the images were made from the same location with the same image alignment on the sensor, the files will align in Photoshop. You have two choices about how you will create layering: you can layer the whole image or a selected area of the image. If the whole image is copied and used in the composite, the

Left—Five layers were used to create this image. Because we needed to deal with a surface color on the marker shafts, diffuse frontal light was needed. However, a frontal light would cause bright white reflections on the plastic tops, obscuring the color. For the color of the tops, we needed two types of lighting, black-line for their filtered color and directional, specular top light to establish a white-line effect to show the interior details. We also needed to create the background and illuminate the plastic container. After the composite was created and flattened, perspective control was applied and the image was straightened. Photograph by Glenn Rand. **Facing page**—Kevin Osborn used classic black-line lighting to capture this splash. The background was lit with a low-powered (therefore, higher speed) flash unit, and the flash and shutter were triggered with an infrared beam synchronized timer. Because of the black-line lighting in the studio, the actual direction of the splash is not apparent. More examples of photographing water in the studio appear in chapter 8.

unwanted portions will have to be erased. Though this approach works, it is time consuming to remove the unwanted portions. It may be a better idea to select only the portion of the image that will be composited. If possible, try to include a corner of the image in the selection, as this will make aligning the two images easier. If the selection does not include a corner, you can zoom in for a close view (e.g., 1800% view) and nudge the selection into the proper alignment. No matter which method you choose to align the images, note that no effect should be applied to any layer prior to alignment with the master file.

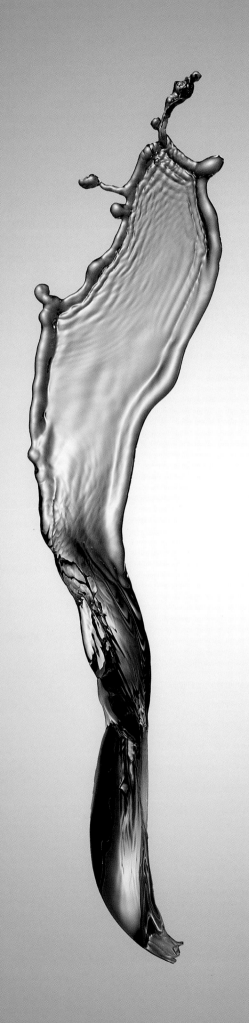

PHOTOGRAPHING WATER

Water is more commonly part of a scene in the natural environment than indoors, but it can come into play in the studio. Even so, in the studio, though water may play an important role in establishing the feel of an image, it is not usually the primary subject. When the water is the primary subject, it most commonly appears in a white-line form. That means that it is seen through the reflections on the surface rather than by the light and subjects transmitting through it.

The surface shape (the motion of the water), the water's clarity (what is reflected in it), and the camera's exposure speed can affect the way the image is rendered, since all of these factors impact the water's reflectivity, transparency, color, and clarity.

Water photographs much like glass. Though we have some control over lighting in the studio, in nature, we must accept what is presented to us and make our images based on these local conditions. Rather than adjusting our lights, we must use the angle of view and exposure to manipulate light's effects. Though local conditions determine what can be captured, we must approach water photographically in much the same way we approach glass. Reflections from the surface and the water's transparency are captured based on the relationship of reflections to the transmitted background.

If the reflections on the water are brighter than the water's tone (whether the tone is created by density, depth, or bottom tone), then the reflections will show as light intensities on top of the water and obscure less intense detail below the water. When the surface reflection is less intense in illumination value, the underwater detail will show. These are an adaptation of the simple rules that govern white- and black-line lighting for glass.

WHEN THE WATER IS THE PRIMARY SUBJECT, IT MOST COMMONLY APPEARS IN A WHITE-LINE FORM.

STOPPING WATER

Often the first image we seek to capture is one of dramatic crashing water—whether it's the waves crashing on the rocks, river rapids, or a waterfall. We are interested in seeing the water as suspended motion. It is important to re-

The look of the photograph is is dependent on the way the light reaches the waterfall and the rocks. Diffused light came from the clear sky, and the sun backlit the scene without falling directly on the waterfall or rocks. This lighting scenario ensured the rocks were rendered dark and created a white-line effect on the water. The shutter speed was fast enough to stop the motion of the water. Photograph by Glenn Rand.

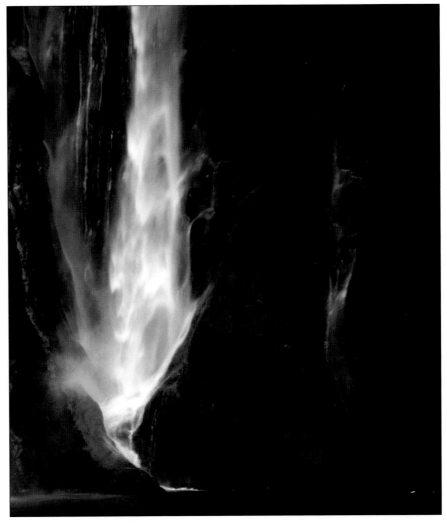

alize that distance from the crash, the direction of travel of the moving water, and the shutter speed will determine our success in stopping the splash and freezing motion. As the distance increases, the stopping ability of any shutter speed is improved. When the motion of the water is moving across the camera's view, there is a need for a faster shutter speed to stop the motion.

While stopping the fast-moving water in nature generally illustrates the power and majesty of the ocean or rushing rivers, there are many other phases of water and ways to approach them that provide wonderful images.

When water moves smoothly or is calm, its surface is like plate glass. As the angle of view becomes closer to parallel to the water surface, it becomes more like a mirror. Similar to glass, if the background is dark, the water shows reflections as light patterns. To build reflecting ponds, the bottom material is normally dark, and the depth of the water is kept shallow to diminish wave size. When the water is calm, the dark background establishes the conditions for a pure, mirrorlike reflection off the top of the water.

When there is slight motion (e.g., small, smooth waves) and the angle of view is close to the surface, dark reflections start to appear in the water. These appear because the surface of the water is reflecting various parts of the envi-

AS THE DISTANCE INCREASES,

THE STOPPING ABILITY OF ANY

SHUTTER SPEED IS IMPROVED.

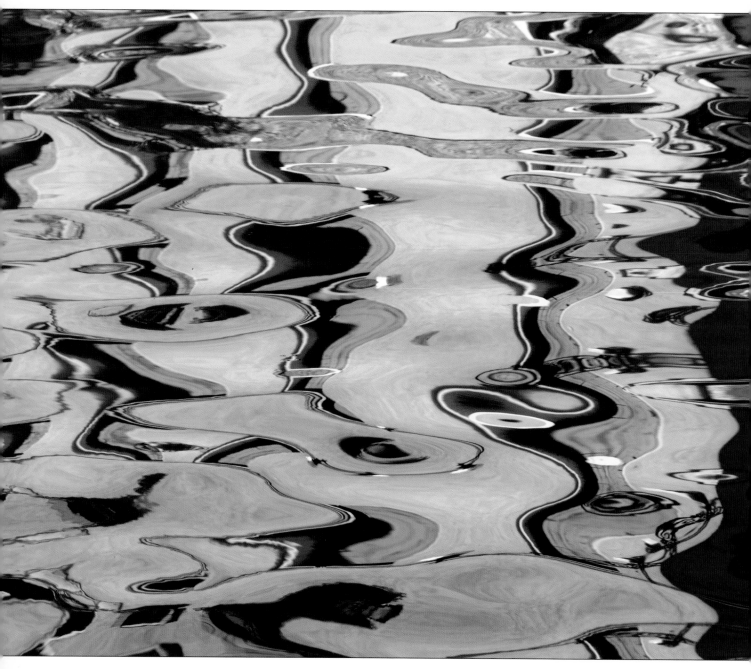

This image by Ian MacDonald-Smith shows the reflection of the motion of the water's surface and its deformation in the image. A fast shutter speed ($1/250$ second or faster) caught the distorted reflections.

ronment that block the intensity from the sky. The maximum darkness on the water is the tone or darkness of the water.

Often when there is slight motion or an unsettled surface, ripples and small, smooth waves are created. As the surface is lightly disturbed, the ripples are low with long, shallow waves. This gives small distortions that have slight bending of reflected or transmitted lines and shapes. Light directed at or through the water is also bent or reflected unevenly by these waves or ripples. Small surface disturbances are more apparent with the camera angle closer to parallel to the water's surface.

As the camera's angle is moved closer to perpendicular to the surface, it is easier to see through clear water where there are no intense reflections. In this situation, the sky's intensity commonly reflects across the water. If the sky reflection is blocked or the intensity of the sky is not bright, then objects of greater light intensity will be seen through the water. With small, smooth waves or ripples, objects under the water's surface will show diffraction

A wide-angle lens was used to take this image. It created a variety of light angles between the scene and the camera. Because the water was calm and the camera angle was near perpendicular to the water's surface in the lower portion of the frame, the underwater material is visible. With the wide-angle lens, the angle of view at the top of the image is closer to parallel. The water reflects the sky's lightness, and the darkness of a backlit cliff is reflected in the upper-right corner. Photograph by Glenn Rand.

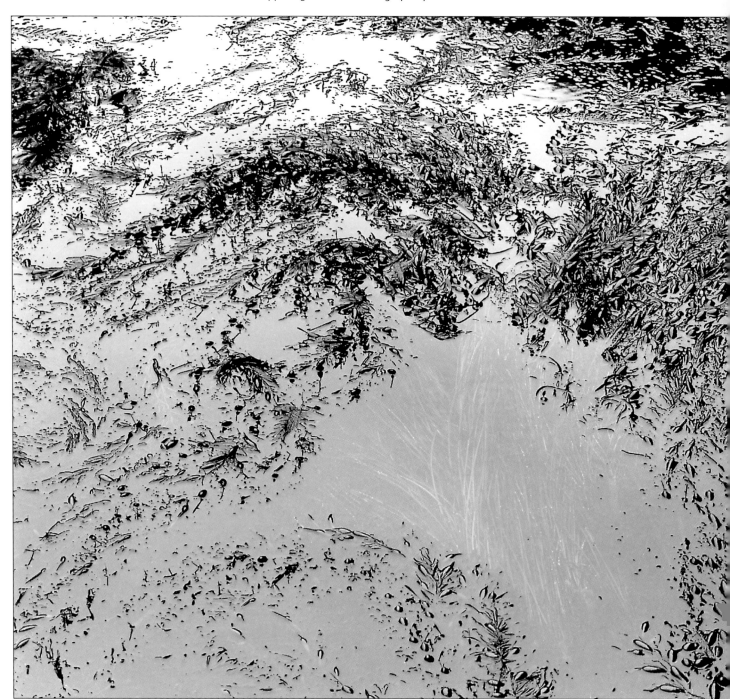

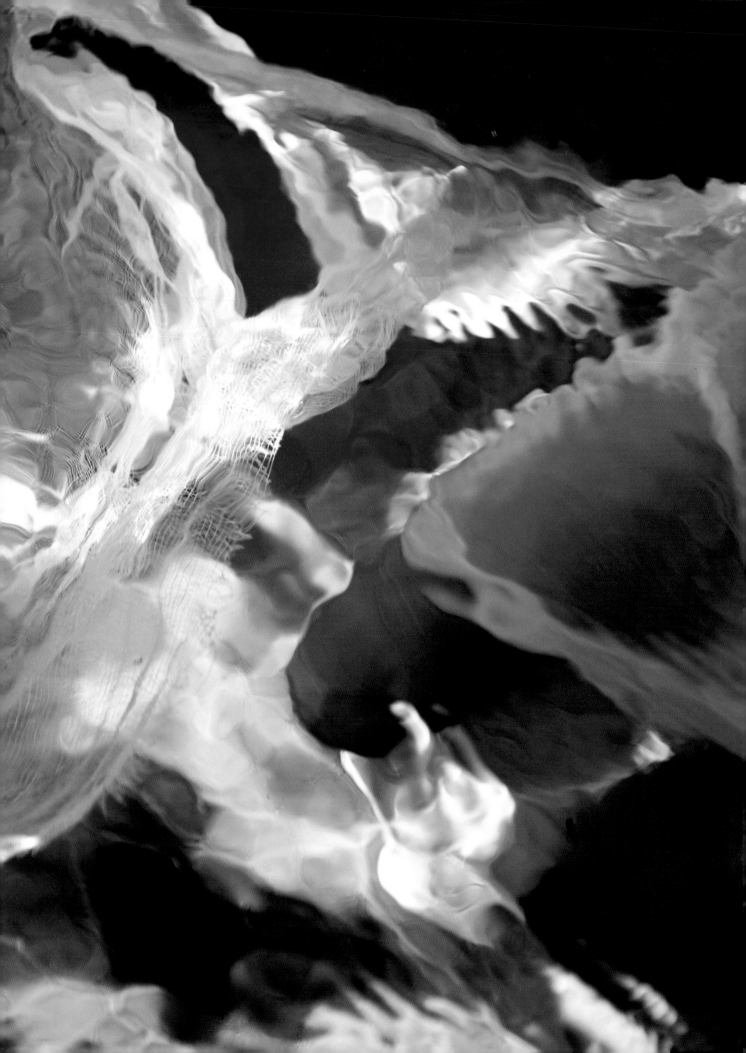

through the distortion of the image captured. This is most noticeable at the edges.

Even if the water is moving rapidly, the motion does not always create perceivable ripples or waves, and the surface acts like plate glass. For example, if a river is moving fast but smoothly, or water is pouring swiftly, it can be seen as a sheet with a smooth surface. If the angle of view is close to perpendicular, then small, smooth waves or ripples will not appear in moving water.

With further disturbance, the water's surface becomes very chaotic, rippled, and forms choppy and steep waves. At this point the water, close up, does not produce sharp reflections, though from greater distances the water has a diffuse reflection. Normally wind and water moving create the disturbance on the water's surface. As the wind or movement becomes more intense, the surface of the water becomes textured, and the reflections are only bright speculars if they exist at all. Because of the chaotic surface, reflections are not crisp and have few details.

Though we will not address underwater photography in this book, it is worth mentioning that there is a special condition that exists when photographing from under the surface. When the camera angle is greater than the

Facing page—Taken from above, this photograph by Victoria Ruderman shows the water's small, uneven waves that refract and distort the image seen below the surface. The refraction is most noticeable on the edges of the subject and as the mottled light patterns on the bottom of the pool. **Above**—The water in this image had an oil slick that changed the reflective characteristics of the pond. Photograph by Glenn Rand.

Facing page—Because the photograph was made looking down at clear, smooth, fast-moving water, with a reflective background of dark trees, there were no bright reflections on the water's surface, and the grass and underside of the river are clear. The lightness of the material is determined by where it is in relation to the surface. The closer to the water's surface, the more light reaches the detail, and thus the detail is brighter. Photograph by Glenn Rand. **Above left**—This half-second exposure shows various aspects of moving water. In the foreground is the streaking of the moving foam, which becomes less distinct as it moves toward the back of the image. Because of the direction of travel and distance, the crashing wave in the background looks almost stopped. Also, the diffuse nature of reflections from the choppy water in the distance is seen. Photograph by Glenn Rand. **Above right**—This photograph was made while the pool was being cleaned. The image is complex, because the photograph shows the reflection on the smooth surface of the water, some objects floating on top of the water, and the pattern of the pool sweeper across the bottom of the pool. Because the area cleaned on the bottom of the pool is lighter, the reflections over these areas are less intense. Photograph by Glenn Rand. **Right**—A telephoto lens was used to keep the angle of view close to parallel to the surface of the water. Since the water was near calm with only a small amount of movement, the ripples on the surface distorted the reflections slightly. A short exposure was selected to stop the water's motion. Photograph by Glenn Rand.

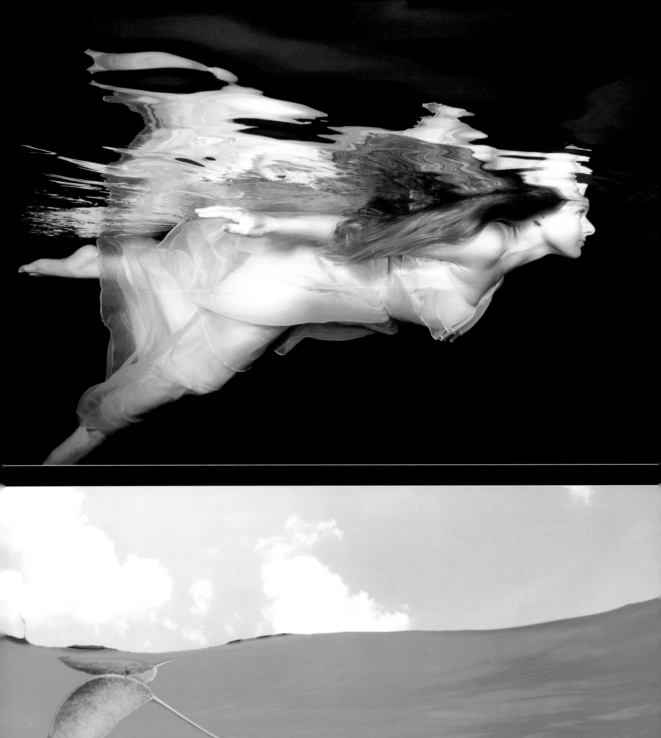

Facing page—(top) In this image by Matthew Meier, the camera is near the surface and thus is beyond the critical angle. Therefore, the undersurface of the water reflects the subject and the darkness of the pool. **(bottom)** Renée Vento made this image by positioning her underwater housing so as to allow simultaneous capture of an area above the water's surface and below the surface. Because her point of view was close to the surface, the floating leaf's reflection is seen on the underside of the water. With the surface of the water having small waves, where the wave brings the angle of view greater than the critical angle, some light from the sky comes through, creating light areas. Where the waves have an angle less than the critical angle, the darkness from the distance is reflected as the leaf. **(right)** In this very long exposure (over 8 minutes), the surf moves from the ocean over the dark rocks up to the buried rock in the foreground. Because of the length of exposure, the foam softens the detail at the rocks' bases, while the moving water provides soft reflection across the sand. Photograph by Glenn Rand.

critical angle (measured from the perpendicular to the undersurface), the underside of the surface acts as a mirror. This means that when the angle of view is closer to parallel than the critical angle, no light will transmit from above the water and reflect from the bottom or subjects beneath the surface.

LONG EXPOSURES OF WATER

Because the surface condition is created by motion, the length of exposure affects both reflection and transmission of light. With a long enough exposure, the light reflecting from the surface of the moving water will take on the look of a reflection from the satin surface. This happens because the water's chaotic moving surface structure reflects the light smoothly but unevenly. The long exposure makes the water's surface look smooth and uniform with diffused reflections.

The rapid motion of the water and crashing of waves create foam. The foam either becomes a pattern on smooth, still water or light streaks and lightened areas on the surface. With a long exposure of the moving foam, the whiteness

Christopher Broughton shows us evidence of slight motion in the water in this long-exposure image. The length of exposure and the slight surface motion reduces reflected detail and smooths the sky's reflection in the water. It also creates soft edges in the reflections from the boats, dock, and pilings.

becomes a fog by breaking up the image from areas projected through the travel of the foam. With shorter exposures, depending on the speed of the water, foam will make streaks and lines.

The darker the surface, the easier it is to see wetness on an object. Depending on the amount of humidity on the surface, the reflectivity will change. As the surface becomes moister, it becomes more specular, and color

Top left—The foaming rushing river is seen as streaks. The water does not reflect since the surface is covered by foam. The rock on the left becomes highly reflective due to its wetness. Photograph by Glenn Rand. **Top right**—The long exposure (18 seconds with filtration) creates the smooth streaks from the waterfall in the background and some of the splash from the rock in the foreground. Part of the splash sends streams through an area of light piercing a leafy overhang. Where the stream of water passes through one of the beams of light, the stream takes on a white-line effect in small areas. These create what look like droplets. Photograph by Glenn Rand. **Bottom**—

The exposure was long enough to allow the surf to flow in and out. The water and foam completely covered the rock in the foreground. The light reflected by the white foam as it moved through the frame produced the light foggy patterns. The wet, specular rock surfaces show the reflection of the sky. Photograph by Glenn Rand.

outside direct reflection will be richer and more saturated. When a wet look is desired, a photographer will often spray or sprinkle water on the subject. To give the water a fuller look, it can be mixed with a more viscous material such as glycerin, and the surface that the droplets will be on can be waxed or smoothed to increase the surface tension, rounding the droplets.

STUDIO PHOTOGRAPHY OF WATER

All of the discussions pertaining to lighting in natural environments applies to photographing water in the studio. However, photographing water in the studio is often more an issue of containment than lighting.

For this photograph, a dark-glass bottle of cologne was used. The bottle's design presents several lighting problems. First, the glass is not totally opaque, so the background, if light, will show through. Next, the labeling on the bot-

TO GIVE THE WATER A FULLER LOOK, IT CAN BE MIXED WITH A MORE VISCOUS MATERIAL.

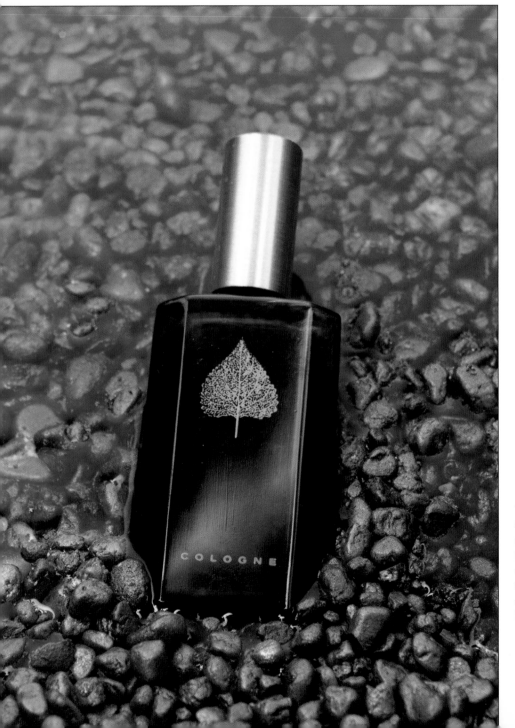

To create a look that would accent the logo and leave space for type, the image was designed with a patterned background with interesting color. Water was chosen to allow coloration without detracting from the bottle. A black pebble ground was selected to contrast with the geometric shape of the bottle. Photograph by Glenn Rand.

Diagrams—(top) The bottom of a large tray was covered with pebbles. More pebbles were placed in the front of the tray. The bottle was placed into the tray so that it was perpendicular to the camera's axis and the camera would not see any of the tray. Water was added until it was level with the bottom of the bottle. **(center)** A card was placed near the camera and lit with a spotlight, which created a pattern on the card. The light was positioned so that the pattern would reflect onto the logo. The pattern created a blush across the bottle. Because a dark-glass bottle was used, white lines naturally occured. **(bottom)** The background was lit with a spotlight fitted with a combination blue/magenta filter. The magenta portion was lower, and thus reflected off the water at the top of the image. The blue served as an accent. Either continuous or electronic flash can be used; however, if the water is to show waves, flash must be used.

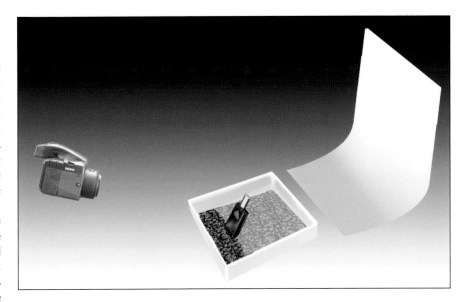

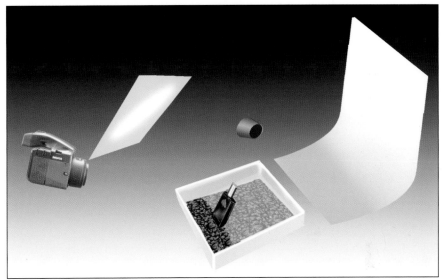

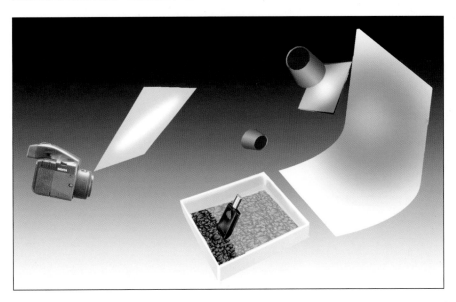

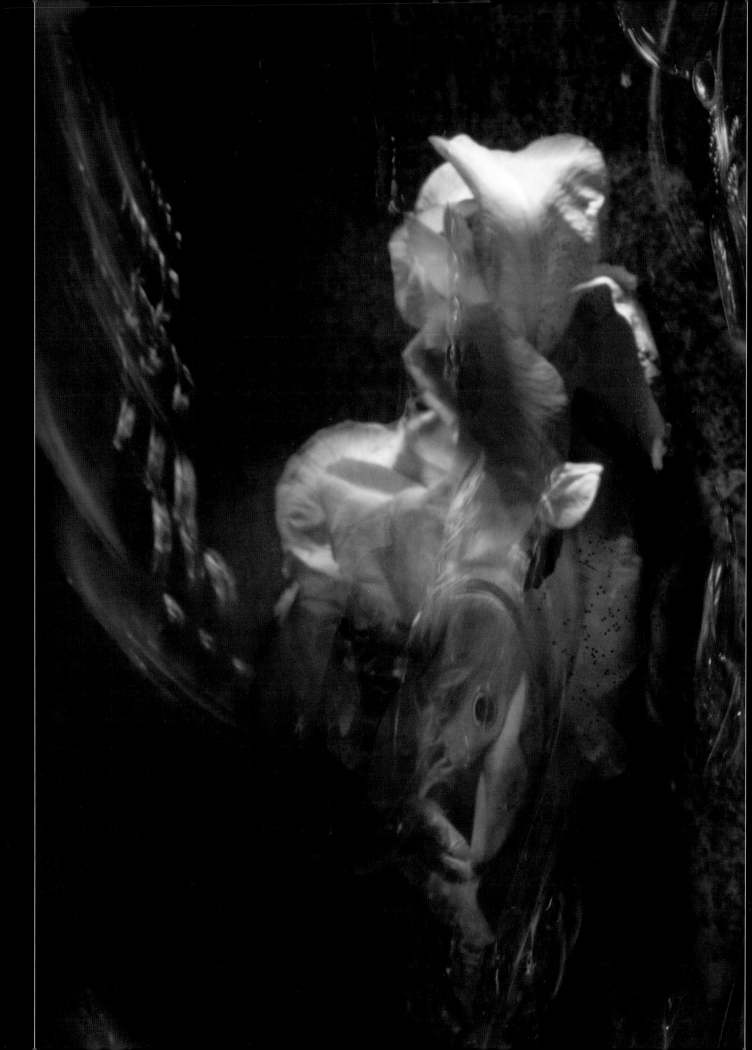

Facing page—Using a long exposure of a reflection in water with motor oil floating on top created this impressionistic image. The oil created the motion effects. A slightly diffused spotlight was used to light the image. Photograph by Glenn Rand. **Right**—The setup was a black shallow tray filled with water. A piece of patterned granite was set vertically as a background with the iris held in front of the granite. Once the lighting was defined and limited to the intended area, motor oil was poured onto the surface of the water. The water's surface was stirred gently prior to making the long exposure.

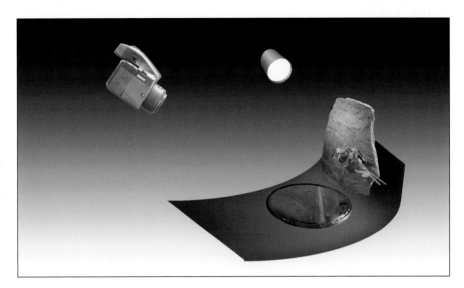

tle and top are metallic. Lastly, the image design puts the bottle in water. These problems need to be solved separately in ways that will not compromise the solution of other parts of the lighting puzzle.

When photographing colognes and perfumes where the bottle's look is important, it may be necessary to remove any tubing used for atomizing the liquid. Normally, the tubing is a light-colored or white plastic that will show through all but the darkest glass. Also, when the perfume is placed into the bottle it is not completely full. This leaves a small bubble visible whenever the bottle is not vertical. The remedy for this situation is to add liquid to the bottle to eliminate the bubble.

MIXING OIL AND WATER

In the studio, water can be used to create images that cannot exist easily in the natural environment. The image shown on the facing page was conceptualized while photographing in the natural environment but was created in the studio where there was greater control.

The concept of the photograph is impressionism. The idea was to allow oil floating on the top of the water to be put into motion to create variation in the reflected image. Because the motor oil would pool and form floating bubbles, its movement across the reflection of the flowers would distort the reflection and create other light patterns as part of the reflection. Also because oil is more viscous than water, it dampens wave formation. This would result in a tighter reflection.

IN THE STUDIO, WATER CAN BE

USED TO CREATE IMAGES THAT

CANNOT EXIST EASILY IN THE

NATURAL ENVIRONMENT.

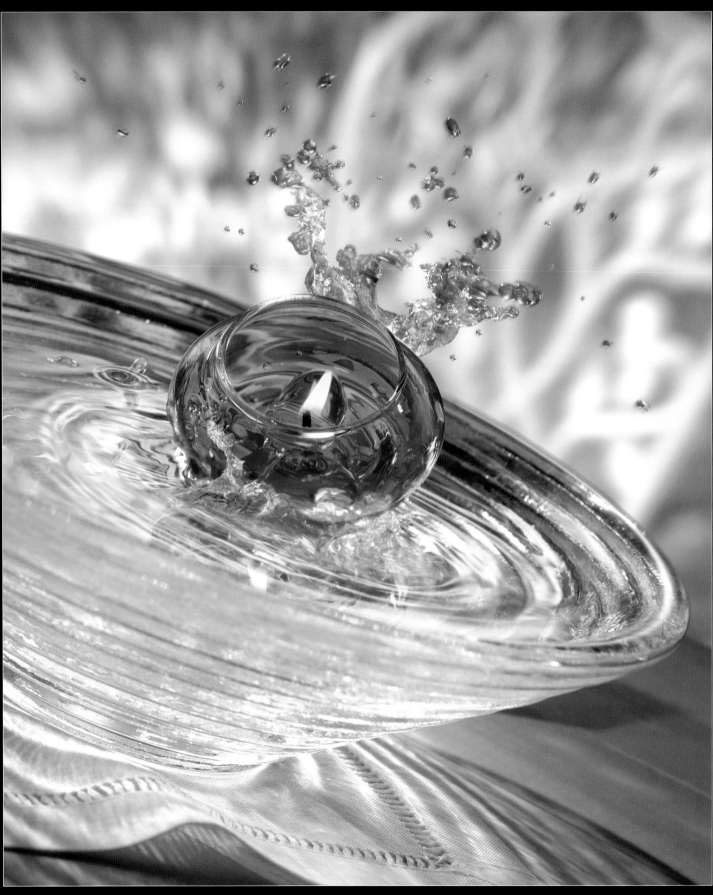

OPTICS

When we look at glass, it is obvious that light's interactions with the surfaces and the way light is transmitted through the glass creates both opportunities and problems.

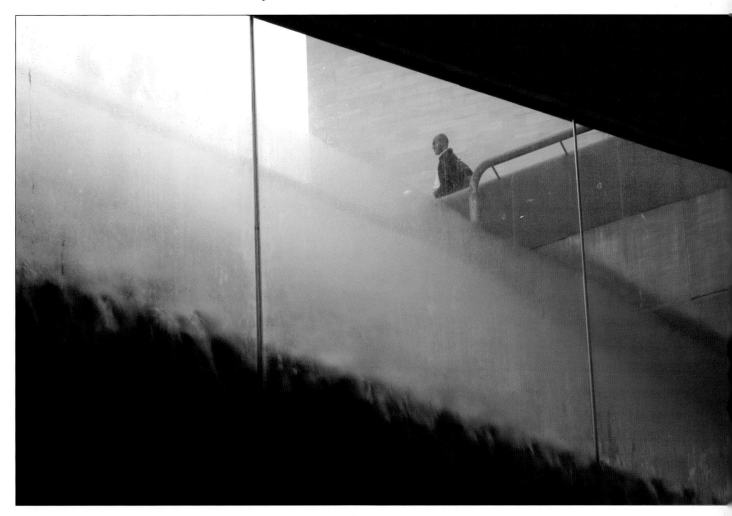

Facing page—In this image by Ralph Masullo, an infrared-triggered flash was used to capture the instant of splash. The lighting is set up to accomplish the desired look on the glass and water. When the falling water passes through the infrared beam, the system is activated, discharging the electronic flash and activating the camera's image sensor. **Above**—Photograph by Glenn Rand.

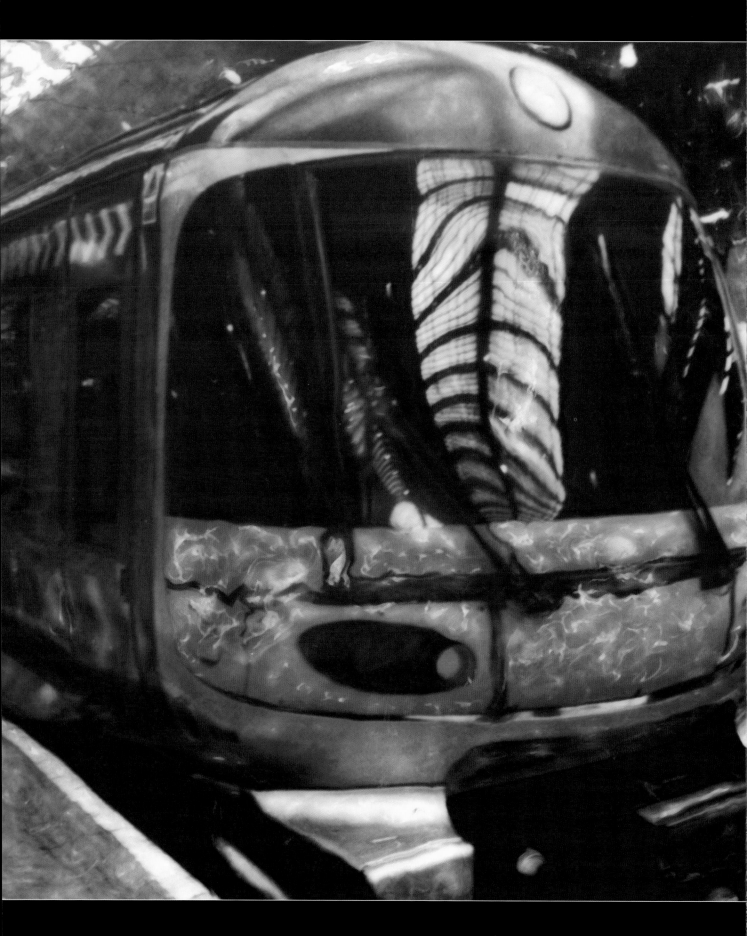

Facing page—This image is a manipulated Polaroid. However, the curved reflection is the result of the convex surface of the windscreen. Photograph by Victoria Ruderman. **Right**—This image shows both the reflections and transmission of the light. The photographer was standing between two parallel windows. The scene, shot through the window, includes a chimney and angled roofline, shown against the sky. The reflection is the window across the room, with the photographer standing in front of the window. Because the light outside the reflected window is brighter than the sky transmitting through the first window, the window behind the photographer shows shows as a light pattern. Where the photographer and the details in the window are silhouetted, the sky and chimney come through the first window, looking dark compared to the relected window. Photograph by Dan Wheeler.

Optics is at the center of any discussion of how to photograph glass. Rather than taking an extensive, scientific look at optics, let us take a less stringent view to lay out how light interacts with subjects. With this accomplished, we'll understand how these issues create opportunities for photographs.

THE BASICS

There are seven basic ways that light interacts with the elements in the environment. These interactions are optics. Without them, photography would not exist.

As light acts together with or illuminates objects, all or part of its energy is changed by being absorbed, passed through, or redirected by one of more of the seven optical functions: transmission, absorption, reflection, refraction,

dispersion, scattering, diffraction, and polarization. When dealing with transparent and translucent subjects, some optics are involved with the way the subject looks. All of the interactions (optics), however, are used in controlling the lighting.

TRANSMISSION AND ABSORPTION

Important to any discussion of transparent and translucent subjects is how the light interacts with an object as it enters and passes through or is absorbed by the subject. Absorption need not be total but is related to the color of the glass and its density. In this way, we can have objects that transmit a portion of the light entering and absorb the remainder.

Our perception of the color of a glass subject is based on transmission and absorption. When light strikes an object, some of the light waves are absorbed, and others are transmitted. The color of the wavelength reflected back (or transmitted, in the case of filters) produces the sensation of color.

The more coloration in a transparent and translucent material, the more complete the absorption. The density of a material is controlled by the tone,

Above—These plastic clips show how absorption and transmission function. The light was from the back, and where there is light behind the clips, the color is seen; where the light transmits through to the foreground, the light shows the absorption by the color of the light reaching the paper. Photograph by Glenn Rand. **Facing page**—In this image, we see the pattern of the sunlight passing through a stained glass window and projecting on the columns. We can also see the color in the stained glass window in the background. Both effects are due to absorption and transmission. Photograph by Glenn Rand.

color, and type of the material. Generally, the darker, more saturated, and denser the material, the greater the absorption. As the color of an object approaches black, the object absorbs more light. You will feel this if you wear a black shirt on a sunny day. Though black objects absorb the most light, even "clear" glass will absorb a small amount of light.

Though most of the light striking glass will be transmitted and/or absorbed, with most materials, a small amount will be reflected. Even though the surface may be very highly polished, provided that the glass is clear, the vast majority of the light will enter the glass. Though the actual percentage of reflection varies from one type of glass to another based on its composition or surface, it is a small amount compared to all the light striking the surface. Only about 4 percent is reflected from common glass; that leaves about 96 percent of the light to enter and be transmitted or absorbed.

REFLECTION

Highly polished surfaces on the glass create specular or directed reflections. Though reflections from the surface of glass are crisp when the glass surface is smooth, the reflections will be irregular or distorted when the surface is nonplanar.

If the surface is smooth or polished, a point source light will reflect as a specular "hot spot." When the surface is textured, the light will be scattered in many directions beyond the direct or specular reflection, becoming more diffuse and spreading the reflection across the surface. Light reflecting from a textured surface is also diffuse. This is the principle behind nonglare glass.

One of the most important principles used in lighting glass is that the angle of incidence (the angle at which the light strikes the glass) is equal to the angle of reflection. The angle of incidence and angle of reflection are measured from a perpendicular at the point where the light strikes the glass. The perpendicular is used because it can take into account a surface that is not flat.

Reflections can occur whenever light intersects with a change in medium. Reflections only happen on the surface between two media. Therefore, reflections can appear when light interacts with glass or on the surface of water. It is important to realize that these reflections occur on both sides of the change in material. Therefore, a reflection can happen on a camera-facing surface of a wine glass, on the inner surface of the glass with the light passing through the wine, or within the glass itself. Though internal reflections seldom affect photography, when the reflective boundary is in a medium with a higher refractive index (the amount of bending created by entering the medium), then it is possible to have all the light reflect and stay within the material. For example, if underwater looking at the surface with a great enough angle of incidence at the surface, all the light will reflect off the underside of the water.

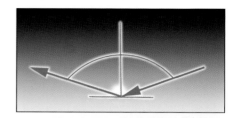
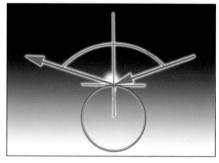

Top and bottom—The angle of incidence and angle of reflection are both measured from a perpendicular at the point where the light strikes the surface. For a cylinder or nonplanar surface, the perpendicular is defined as the line originating at the center of curvature passing through the point where the light strikes the surface of the curved object.

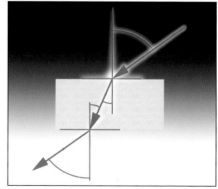

Top and bottom—The angle of refraction, once the light enters the glass, is diverted toward the perpendicular because the glass has a higher refractive index than the air. As the light exits the parallel surface of the glass, it reverts to its original angle.

Left—J. Seeley placed eyeglasses frozen inside of a block of ice on a scanner. As the ice melted, several images were made. This image shows dispersion as the light reflects back from the aluminum plate behind the block and passes through the lenses of the glasses. **Top and bottom right**—As blue and red light strike the glass in parallel paths, they are refracted at different angles. When the two paths exit the glass, both light paths revert to the angle of incidence but are now separated (dispersed). When the second surface is planar but not parallel to the incident surface, the light spreads farther because as they exit, the angle of refraction of each path varies based on its wavelength.

REFRACTION

Refraction is the bending of light as it passes through materials of different densities. When the light moves from a less dense medium to a denser one, it bends toward the perpendicular at the point of incidence. When the light moves from a dense medium to a less dense medium, it bends away from the perpendicular. The amount of bending is dependent on the relative refractive indices of the two media, the angle of incidence, and the color of the light.

The degree of bending can be defined by an equation that employs the wavelength of the light and the ratio between the refractive indices of the two materials. Based on this formula, we see that the shorter the wavelength (violet, blue etc.), the greater the amount of refraction. Also, because densities reverse as the light exits, after the light passes through a glass plate with parallel surfaces, it will exit at the same angle as the incident light.

Lenses work because of refraction. The light direction will be restored when it exits a surface parallel to its entry, but it will deviate if the surfaces are not parallel. When the surfaces are farther apart in the centers of a lens, the refraction of the light is concentrated (i.e., focused); if the outer edges of a lens are thicker than the center, the light will spread. Though

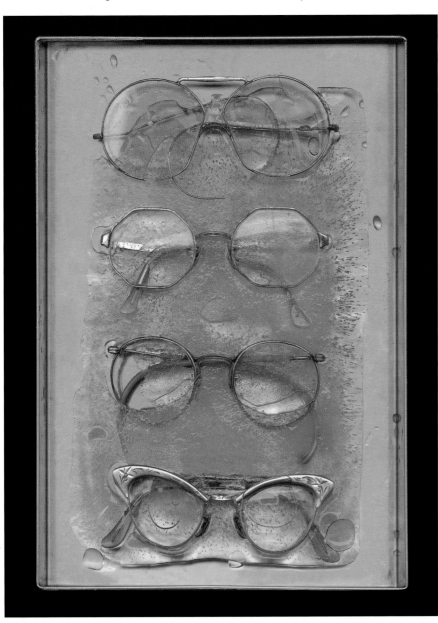

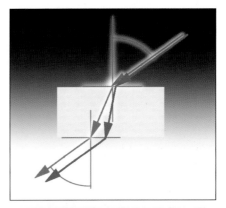

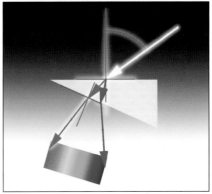

this concept is very important for lenses, it also comes into play when light is shown on the glass being photographed.

DISPERSION

Dispersion is refraction at different wavelengths. This means that various wavelengths will bend in varying amounts, and this will disperse, or separate, light by its color. When white light passes through glass with parallel surfaces the dispersion may not be seen, because as the light exits, the various wavelengths remix to form white light. However, if the surfaces are planer but not parallel, dispersion of white light based on its wavelengths creates a spectrum as blue refracts more and red less. This is the principle of a prism.

POLARIZATION

Light travels in waves. In most situations, the light waves have no specific orientation in relation to their axis of travel. There are times when the light takes on a particular characterization where all the waves have the same orientation about the axis of the light. In such a case, the light is said to be polarized.

Light can be polarized by reflection off a nonmetallic surface such as glass or water. When this occurs, the light's wave pattern is shifted to a point where all the waves have the same attitude as the surface from which they were reflected.

The effect of polarized light can be seen when using polarization filters. These filters are made up of micrometallic crystals that are arranged in parallel lines. Because of the structure of the filter's micro-metallic particles, light at a specific orientation will be transmitted, and all other orientations will be absorbed and blocked. Since light reflecting from a shiny transparent surface, such as glass or water, is polarized, a polarizing filter can be used to block the light reflecting from the surface, allowing you to see through the surface. Polarizing filters also come in handy to reduce reflections from the surface of glass, allowing you to see an object through the glass.

Facing page—This image by John W. Gutowski (1948–2001) used polarized light to create the color. The image shows various plastics and polarized light passing through the assemblage with a polarizing filter on the camera's lens. The colors relate to the amount of stress within the structure of the plastic as well as other distortions and colors. Photograph from the collection of Glenn Rand. **Below**—This image shows the background through open space (no glass), clear glass, lightly smoked glass, and heavily smoked glass. This gives a clear view of the background trees where the glass is broken out or is clear and allows for various stages of translucency where the glass is smoked in various degrees. Photograph by Glenn Rand.

DIFFRACTION AND SCATTERING

The least commonly encountered optic interactions for lighting glass are diffraction and scattering. Diffraction happens when light passes by an edge or very small features (such as those on CDs or DVDs). Any edge, whether on an opaque object or just the edges created by differences in densities, can cause diffraction. The diffraction deviates the light's path, and the closer together the edges that are diffracting the light, the more apparent the effect. Unlike refraction, the longer wavelengths diffract more than shorter wavelengths. Red, for instance, diverts more than blue.

Scattering is caused when the light path is diverted by particles in the air, within a transmitting material, or at a reflecting surface. Unless the glass is in an environment with particles in the air, such as smoke or fog, this will have little impact on the lighting of glass. However, scattering will be needed if a light path is required to be seen in an image. Scattering is more important in photographing glass, as it creates diffuse light and/or reflections.

Facing page—In this image, the reflection and color is modified by an oil slick on top of the water. The distortions of the subject are due to the shallow waves in the water, and the color distortions and patterns are induced by diffraction from the oily surface. The sky's diffused light encourages the diffraction color patterns on the water. Photograph by Glenn Rand. **Below**—This scene was photographed through a dense fog. The closer the subject matter to the camera, the less scattering of the light. Therefore, the foreground has sharper detail. In contrast, the barn is softened by the scattering of the light, and the far silo appears even softer.

ABOUT THE AUTHOR

Dr. Glenn Rand has taught and administered in public education, community colleges, and universities since 1996. Since 2001 he has taught in the graduate program at Brooks Institute in Santa Barbara, CA, where he serves as acting graduate program chairman. In conjunction with these academic roles and consulting he has developed and reorganized several curricula for fine art photography, commercial photography, digital imaging, and allied curricula. His teaching has included courses in lighting, as well as commercial and fine art photography.

He received his bachelors degree and master of arts from Purdue University. He earned a doctorate from the University of Cincinnati, centering on the psychology of educational spaces, and did post-doctoral research as a visiting scholar at the University of Michigan. Since the early 1980s, his extra-academic research has included computer-based imaging.

As a consultant, Rand's clients have included the Ford Motor Company, Photo Marketing Association International, the Ministry of Education of Finland, and many other businesses and several colleges. As part of his consulting for the Eastman Kodak Company, he traveled and lectured on how to maximize T-Max films when they were first released.

Black & white photographs by Glenn Rand are held in the collections of thirty public museums in the United States, Europe, and Japan and are widely exhibited. His photographs have also been used for editorial, illustrative, and advertising functions.

He has published and lectured extensively about photography and digital imaging, covering topics ranging from commercial aesthetics to the technical fine points of lighting. He is the author of numerous books and contributes regularly to various periodicals, such as *Rangefinder* magazine, of which he is a contributing editor. He is the author of two other Amherst Media titles, *Film & Digital Techniques for Zone System Photography* (2008) and *Lighting for Photography* (2008).

CONTRIBUTORS

CHRISTOPHER BROUGHTON

Christopher Broughton is the recipient of BS and MS degrees in professional photography from the Brooks Institute, Santa Barbara, CA, and has been a faculty member at the school since 1996. While completing his master of science degree, he served as Director of Laboratory Operations at the institute. He also served as faculty for the University of Pittsburgh's Semester at Sea *program in 1996. Broughton has authored articles in Petersen's Photographic, Outdoor Photographer, PC Photo,* and *Studio Photography & Design* magazines and has been a featured lecturer for Hasselblad USA and Eastman Kodak. His black & white photography is exhibited and represented by Jeannie Denholm of Art Matters in Long Beach, CA; Robin Fold of the Golden Orb, CA; the Griffin Gallery in Venice Beach, CA; and the Silver Light Gallery in Carmel, CA.

BOB COSCARELLI

Based in Chicago, Bob has worked with numerous high-profile clients, including Abott, Amgen, Aspen Institute, Aveeno, Baxter, Citibank, L'Oreal, Marriott, MacArthur Foundation, Microsoft, Motorola, Olympus, PepsiCo, Sara Lee, SC Johnson, and USPS. His editorial clients include several well-known publications, including *Chicago, Chicago Home, Cooking Light, CS, CS Interiors, Essence,* and *Men's Health* magazines.

DOUGLAS DUBLER

Douglas Dubler is a fashion, beauty, and fine-art photographer who seamlessly joins craft and creativity to produce some of the most memorable images in editorial, advertising, and fine-art photography. He has been able to achieve this union by synthesizing right- and left-brain thinking. His early training in fine arts and liberal arts at Boston University enriched him with an articulate sense of form, color, and composition. Dubler's early mentors, the famed Japanese sculptor Isamu Noguchi and the renowned American photographer Ansel Adams, reflected his appreciation for the duality of the creative process. His professional photographic career began in the late 1960s in California and the Virgin Islands, where he photographed underwater life. In his early career, he worked for Kodak, Coca-Cola, Rolex, Proctor & Gamble, BMW, Eastern Airlines, Waterford, Johnson & Johnson, and Hasselblad. In 2002, with the strong emergence of digital photography, Douglas transitioned almost totally to digital capture. The ability to meld technology with creative imagery has firmly established Douglas Dubler as an innovator and artist and will continue to create a constant demand for his iconographic beauty and fine-art images.

MARY EHMANN

Mary Ehmann does her photographic work in Haslett, MI. She studied photography at Lansing Community College and earned a BA at Adrian College.

JOHN W. GUTOWSKI

John W. Gutowski (1948–2001) was associate professor of fine art at the University of Missouri–Kansas City, where he taught and produced his photographic art.

JOE LAVINE

Joe Lavine is a commercial photographer specializing in food and beverage images, living in Golden, CO. For twenty years, Joe has worked with his clients in his studio on Santa Fe Drive, the growing (prominent) art and photo district in Denver, CO. In addition to creating commercial work, Joe has been teaching for ten years at the Art Institute of Colorado. Education has always been important in his life; he holds an undergraduate degree from Cal Poly in San Luis Obispo, CA, and a masters degree from Savannah College of Art and Design.

Joe is an Adobe Certified Expert in Photoshop and Beta tester for Leaf America. His expertise in Photoshop allows him to do his own digital retouching and manipulation for his clients and personal work.

Joe's clients include General Mills, Betty Crocker, McDonalds, Red Robin, Quiznos, Rock Bottom Restaurants, Coors, Peaberry Coffee, Wells Fargo Bank, Time Warner Telecom, Qwest, and others. Joe's work can be seen at www.lavinephoto.com.

DAVE LEVINE

After graduating from Brooks Institute, Dave Levine joined Render Unit. The company's primary focus is combining computer-generated photo elements with camera-based images to create unique concepts and illustrations for major car manufacturers, ad agencies, and photographers. Render Unit's state-of-the-art tools and techniques, high-end render machines, cutting-edge software, and an enthusiastic team of creative professionals comprise Render Unit. For more information, go to www.renderunit.com.

IAN MACDONALD-SMITH

Bermudian Ian Macdonald-Smith has been capturing the world on film and digital for more than fourteen years. He specializes in abstract and graphic photography, as well as subjects in landscape, architecture, travel, history, and the environment. His photographs have been exhibited internationally, and he has produced five books, including *Setting Sail for the New Millennium* (Just Clicked Publications, 2001). He is part of the Olympus Visionaries program. Ian attended the King's School, Canterbury, the Bermuda College, and Acadia University in Nova Scotia, Canada.

RALPH MASULLO

Ralph Masullo's passion for photography began at the age of twelve when he developed his first roll of film. It led to a twenty-five year career as a professional photographer and now as an educator. The majority of Ralph's career has been devoted to producing images for advertising and editorial purposes. His client list includes AT&T, American Express, Citibank, Johnnie Walker Scotch, Nikon, Sony, Toshiba, Visa, and Ziff Davis Publishing, to name a few. Ralph's commercial work has been called "stunningly handsome," bold, colorful, and fun—a reflection of his personality. He received his BFA degree in photography from the School of Visual Arts, NYC, in 1980, and he is currently enrolled in an MFA program in photography. Ralph operates a commercial still life studio in Manhattan and teaches photography at Briarcliffe College in Bethpage, NY.

MATTHEW MEIER

Matthew Meier is a professional freelance photographer living in San Diego, CA. He was formally trained at the Brooks Institute in Santa Barbara, CA. Matthew's work has been employed by the Ocean Channel, the National Marine Sanctuaries, the National Marine Sanctuary Foundation, ThankYouOcean.org, NANPA Impressions, JCK, Professional Jeweler, Timothy Meier Design, and on Broadway. He is a member of the American Society of Media Photographers (ASMP), the North American Nature Photographers Association (NANPA), the Ocean Communicators Alliance (www.thankyouocean.org), the Sierra Club, and the University of Michigan's Alumni Association.

TIM MEYER

After twenty-seven years of success with his portrait/wedding studio, Tim Meyer became the chair of the portrait program at Brooks Institute. Tim has been honored as a Master of Photography, Photographic Craftsman, and Certified Professional Photographer. Tim Meyer received both his BA and MA degrees in photography from California State University–Fullerton. Though a full-time educator, he stays active in portrait and wedding photography and is a Fujifilm Talent Team member.

KEVIN OSBORN

Kevin Osborn is currently working on his MFA at Brooks Institute. He holds a BA in computer science from UC Santa Cruz and a BS in natural resources from Humboldt State University, CA. He also teaches introductory math at Brooks Institute. Kevin specializes in commercial, nature, and industrial/scientific photography.

MICHAEL RAND

Educated at the University of Michigan with his Master of Arts degree from Southern Cross University in Lismore, Australia, Michael has exhibited and had his work collected by museums in the United States. His illustrative and travel photography has been published in several magazines.

NEIL RANKINS

While at CSU Chico in 2000, Neil's interest in photography exploded after a requirement for his major in Applied Computer Graphics that he take a photography class. It became a passion. After completing his degree at Chico State in 2004, Neil packed up all his worldly belongings and moved south to Santa Barbara to attend the prestigious Brooks Institute. The result is a more refined eye and a never-ending exploration of the infinite possibilities in photographic abstraction when applied with a kid's imagination. His current project came about from an assignment in an industrial/scientific class at Brooks Institute. Neil says, "I just ran with the polarization technique and explored how to take it further. It really is about multiple techniques and compositions; some isolate shapes on a simple background while others are more interactive regarding color, shape, and line. While the compositions are deliberate, the intention was to produce images of a playful nature."

DAVID RUDERMAN

David Ruderman's interest in black & white photography began fifty years ago. Like many photographers, David is transitioning to digital photography, though his love and photographic experiences are heavily weighted with his black & white photography. His work accelerated while in the Peace Corps in India where he documented life in a poor part of the country. He works in Sacramento, CA, where he exhibits and has his work published.

VICTORIA RUDERMAN

A fine artist from the beginning, Victoria Ruderman moved from painting, to highly manipulated photographic imagery, to more camera-based photography. Through this transition, her work has been published in the Sacramento, CA, area, where she is renowned for her fanciful and colorful photography.

J. SEELEY

J. Seeley is best known for the three editions of his book, *High Contrast* (Focal Press, 1992). His work has been published in numerous U.S. and European publications, including *Camera, Zoom, American Photographer,* and *The New York Times*. His images have found a place in many college-level photography texts, several design texts, and in several published collections of images. He is represented in numerous public and private collections including the Museum of Modern Art, the High Museum, International Museum of Photography at the Eastman House, University of Iowa Art Museum, Collection of Colorado State University, the Dayton Art Institute, and the Kresge Collection. He is a professor of art and chair of the department of art and art history at Wesleyan University in CT, where he has taught since 1972.

JULIE SPARKS ANDRADA

Julie is a native of California, currently living in Ventura. She has an undergraduate degree from Brooks Institute and is currently enrolled in the MFA program at Brooks,

from which she will graduate in December 2008. She is the principal photographer in Sparks Photography, a portrait photography business in Ventura.

CHRISTINE TRICE

Christine Trice says of her becoming a photographer, "When I was in sixth grade I photographed my playground with a pinhole camera that I made out of a Quaker Oats container. I remember the excitement of watching the image reappear in the developer, as I stood on an old telephone book, peering down into the trays. The entire process of 'shooting,' developing, and printing is a process that I'm still fond of today. Although playgrounds and pinholes still interest me, photographing people is what makes me alive. Meeting them, putting them at ease, and letting that magical flow come about as we exchange energy, glances, and trust is, in my opinion, what real portraiture is. The person in front of the camera has as much to do with a great shot as the photographer, and if the two give their best and if the shutter is snapped at the precise moment, great images will be made." Christine earned an associates degree from Phoenix College in Arizona and a bachelors degree from Northern Arizona University. She became a successful a wedding/event photographer in Las Vegas, NV, and has taught photography at the College of Southern Nevada. She was formally trained in photography at Brooks Institute. Christine currently resides near the coast of New Hampshire.

DAN TROMMATER

Dan Trommater is a graduate of Rochester Institute of Technology, where he earned a BFA, with honors, in advertising photography. He taught a broad range of photography courses at Lansing Community College (his alma mater) from 1997 to 1999. During that time, he shot thousands of photographs of his father and produced a portrait portfolio of him. In 2004, he left the world of professional photography and education. He now earns his living as a magician and puts his photographic expertise to work for self-promotion. You can get more information at www.trommater.com.

RENÉE VENTO

Ocean photography is Renée Vento's passion. Over the past decade she has traveled to Malaysia, Australia, Solomon Islands, Palau, Yap, the Caribbean, Mexico, Hawaii, Panama, Costa Rica, and Europe via her accomplishments in photography. It is Renée's deeply felt belief that through imagery comes awareness, which is what motivates her to shoot. It is her goal to promote the preservation and protection of the ocean's sensitive habitats and wildlife through her lens. Renée's first degree was earned at San Diego State University. She is completing her masters degree at Brooks Institute. Renée currently lives in St. Thomas, USVI.

DAN WHEELER

Dan Wheeler became a serious photographer/artist in high school. In college, he was the chief photographer of the *Yale Daily News*.

After his career as a cognitive psyhcologist at the University of Cinncinnati, Dan has come back to being an artist/photographer. His photographs were recently chosen for a show at the B. J. Spoke gallery in Huntington, NY, and his images are often entered in competition.

INDEX

Other Books by Glenn Rand . . .

FILM & DIGITAL TECHNIQUES FOR
ZONE SYSTEM PHOTOGRAPHY

Learn how to use this systematic approach for achieving perfect exposure, developing or digitally processing your work, and printing your images to ensure the dynamic photographs that suit your creative vision. $34.95 list, 8.5x11, 128p, 125 b&w/color images, index, order no. 1861.

LIGHTING FOR PHOTOGRAPHY TECHNIQUES

FOR STUDIO AND LOCATION SHOOTS

Gain the technical knowledge of natural and artificial light you need to take control of every scene you encounter and produce incredible photographs. $34.95 list, 8.5x11, 128p, 150 color images/diagrams, index, order no. 1866.

MARKETING & SELLING TECHNIQUES

FOR DIGITAL PORTRAIT PHOTOGRAPHY

Kathleen Hawkins

Great portraits aren't enough to ensure the success of your business! Learn how to attract clients and boost your sales. $34.95 list, 8.5x11, 128p, 150 color photos, index, order no. 1804.

MASTER GUIDE FOR
UNDERWATER DIGITAL PHOTOGRAPHY

Jack and Sue Drafahl

Make the most of digital! Jack and Sue Drafahl take you from equipment selection to underwater shooting techniques. $34.95 list, 8.5x11, 128p, 250 color images, index, order no. 1807.

DIGITAL PHOTOGRAPHY BOOT CAMP

Kevin Kubota

Kevin Kubota's popular workshop is now a book! A down-and-dirty, step-by-step course in building a professional photography workflow and creating digital images that sell! $34.95 list, 8.5x11, 128p, 250 color images, index, order no. 1809.

PROFESSIONAL POSING TECHNIQUES FOR WEDDING AND PORTRAIT PHOTOGRAPHERS

Norman Phillips

Master the techniques you need to pose subjects successfully—whether you are working with men, women, children, or groups. $34.95 list, 8.5x11, 128p, 260 color photos, index, order no. 1810.

THE BEST OF FAMILY PORTRAIT PHOTOGRAPHY

Bill Hurter

Acclaimed photographers reveal the secrets behind their most successful family portraits. Packed with award-winning images and helpful techniques. $34.95 list, 8.5x11, 128p, 150 color photos, index, order no. 1812.

BLACK & WHITE PHOTOGRAPHY

TECHNIQUES WITH ADOBE® PHOTOSHOP®

Maurice Hamilton

Learn the skills you need to become a master of the black & white digital darkroom! Covers all the skills required to perfect your black & white images and produce dazzling fine-art prints. $34.95 list, 8.5x11, 128p, 150 color/b&w images, index, order no. 1813.

NIGHT AND LOW-LIGHT

TECHNIQUES FOR DIGITAL PHOTOGRAPHY

Peter Cope

With even simple, inexpensive point-and-shoot digital cameras, you can create dazzling nighttime photos. Get started quickly with this step-by-step guide. $34.95 list, 8.5x11, 128p, 100 color photos, index, order no. 1814.

PROFESSIONAL MARKETING & SELLING TECHNIQUES FOR DIGITAL WEDDING PHOTOGRAPHERS
2nd Ed.

Jeff Hawkins and Kathleen Hawkins

Taking great photos isn't enough to ensure your professioanl success! Become a master marketer and salesperson with these easy techniques. $34.95 list, 8.5x11, 128p, 150 color photos, index, order no. 1815.

MASTER COMPOSITION
GUIDE FOR DIGITAL PHOTOGRAPHERS

Ernst Wildi

Composition can truly make or break an image. Master photographer Ernst Wildi shows you how to analyze your scene or subject and produce the best-possible image. $34.95 list, 8.5x11, 128p, 150 color photos, index, order no. 1817.

THE BEST OF
ADOBE® PHOTOSHOP®

Bill Hurter

Rangefinder editor Bill Hurter calls on the industry's top photographers to share their strategies for using Photoshop to intensify and sculpt their images. $34.95 list, 8.5x11, 128p, 170 color photos, 10 screen shots, index, order no. 1818.

HOW TO CREATE A HIGH PROFIT
PHOTOGRAPHY BUSINESS
IN ANY MARKET

James Williams

Whether your studio is in a rural or urban area, you'll learn to identify your ideal client, create the images they want, and watch your financial and artistic dreams spring to life! $34.95 list, 8.5x11, 128p, 200 color photos, index, order no. 1819.

MASTER LIGHTING
TECHNIQUES
FOR OUTDOOR AND LOCATION DIGITAL
PORTRAIT PHOTOGRAPHY

Stephen A. Dantzig

Use natural light alone or with flash fill, barebulb, and strobes to shoot perfect portraits all day long. $34.95 list, 8.5x11, 128p, 175 color photos, diagrams, index, order no. 1821.

BEGINNER'S GUIDE TO
ADOBE® PHOTOSHOP®, 3rd Ed.

Michelle Perkins

Enhance your photos or add unique effects to any image. Short, easy-to-digest lessons will boost your confidence and ensure outstanding images. $34.95 list, 8.5x11, 128p, 80 color images, 120 screen shots, order no. 1823.

THE BEST OF PROFESSIONAL
DIGITAL PHOTOGRAPHY

Bill Hurter

Digital imaging has a stronghold on photography. This book spotlights the methods that today's photographers use to create their best images. $34.95 list, 8.5x11, 128p, 180 color photos, 20 screen shots, index, order no. 1824.

ADOBE® PHOTOSHOP®
FOR UNDERWATER PHOTOGRAPHERS

Jack and Sue Drafahl

In this sequel to *Digital Imaging for the Underwater Photographer*, Jack and Sue Drafahl show you advanced techniques for solving a wide range of image problems that are unique to underwater photography. $39.95 list, 6x9, 224p, 100 color photos, 120 screen shots, index, order no. 1825.

PROFESSIONAL
PORTRAIT LIGHTING
TECHNIQUES AND IMAGES FROM MASTER
PHOTOGRAPHERS

Michelle Perkins

Get a behind-the-scenes look at the lighting techniques employed by the world's top portrait photographers. $34.95 list, 8.5x11, 128p, 200 color photos, index, order no. 2000.

MASTER POSING GUIDE
FOR CHILDREN'S PORTRAIT PHOTOGRAPHY

Norman Phillips

Create perfect portraits of infants, tots, kids, and teens. Includes techniques for standing, sitting, and floor poses for boys and girls, individuals, and groups. $34.95 list, 8.5x11, 128p, 305 color images, order no. 1826.

WEDDING PHOTOGRAPHER'S
HANDBOOK

Bill Hurter

Learn to produce images with technical proficiency and superb, unbridled artistry. Includes images and insights from top industry pros. $34.95 list, 8.5x11, 128p, 180 color photos, 10 screen shots, index, order no. 1827.

RANGEFINDER'S
PROFESSIONAL
PHOTOGRAPHY

edited by Bill Hurter

Editor Bill Hurter shares over one hundred "recipes" from *Rangefinder's* popular cookbook series, showing you how to shoot, pose, light, and edit fabulous images. $34.95 list, 8.5x11, 128p, 150 color photos, index, order no. 1828.

LEGAL HANDBOOK FOR
PHOTOGRAPHERS, 2nd Ed.

Bert P. Krages, Esq.

Learn what you can and cannot photograph, how to handle conflicts should they arise, how to protect your rights to your images in the digital age, and more. $34.95 list, 8.5x11, 128p, 80 b&w photos, index, order no. 1829.

MASTER GUIDE
FOR PROFESSIONAL PHOTOGRAPHERS

Patrick Rice

Turn your hobby into a thriving profession. This book covers equipment essentials, capture strategies, lighting, posing, digital effects, and more, providing a solid footing for a successful career. $34.95 list, 8.5x11, 128p, 200 color images, order no. 1830.

PROFESSIONAL FILTER TECHNIQUES
FOR DIGITAL PHOTOGRAPHERS

Stan Sholik

Select the best filter options for your photographic style and discover how their use will affect your images. $34.95 list, 8.5x11, 128p, 150 color images, index, order no. 1831.

MASTER'S GUIDE TO WEDDING PHOTOGRAPHY
CAPTURING UNFORGETTABLE MOMENTS AND LASTING IMPRESSIONS

Marcus Bell

Learn to capture the unique energy and mood of each wedding and build a lifelong client relationship. $34.95 list, 8.5x11, 128p, 200 color photos, index, order no. 1832.

MASTER LIGHTING GUIDE
FOR COMMERCIAL PHOTOGRAPHERS

Robert Morrissey

Use the tools and techniques pros rely on to land corporate clients. Includes diagrams, images, and techniques for a failsafe approach for shots that sell. $34.95 list, 8.5x11, 128p, 110 color photos, 125 diagrams, index, order no. 1833.

HOW TO TAKE GREAT DIGITAL PHOTOS
OF YOUR FRIEND'S WEDDING

Patrick Rice

Learn the skills you need to supplement the photos taken by the hired photographer and round out the coverage of your friend's wedding day. $17.95 list, 8.5x11, 80p, 80 color photos, index, order no. 1834.

DIGITAL CAPTURE AND WORKFLOW
FOR PROFESSIONAL PHOTOGRAPHERS

Tom Lee

Cut your image-processing time by fine-tuning your workflow. Includes tips for working with Photoshop and Adobe Bridge, plus framing, matting, and more. $34.95 list, 8.5x11, 128p, 150 color images, index, order no. 1835.

THE PHOTOGRAPHER'S GUIDE TO
COLOR MANAGEMENT
PROFESSIONAL TECHNIQUES FOR CONSISTENT RESULTS

Phil Nelson

Learn how to keep color consistent from device to device, ensuring greater efficiency and more accurate results. $34.95 list, 8.5x11, 128p, 175 color photos, index, order no. 1838.

SOFTBOX LIGHTING TECHNIQUES
FOR PROFESSIONAL PHOTOGRAPHERS

Stephen A. Dantzig

Learn to use one of photography's most popular lighting devices to produce soft and flawless effects for portraits, product shots, and more. $34.95 list, 8.5x11, 128p, 260 color images, index, order no. 1839.

CHILDREN'S PORTRAIT PHOTOGRAPHY HANDBOOK

Bill Hurter

Packed with inside tips from industry leaders, this book shows you the ins and outs of working with some of photography's most challenging subjects. $34.95 list, 8.5x11, 128p, 175 color images, index, order no. 1840.

JEFF SMITH'S LIGHTING FOR OUTDOOR AND LOCATION PORTRAIT PHOTOGRAPHY

Learn how to use light throughout the day—indoors and out—and make location portraits a highly profitable venture for your studio. $34.95 list, 8.5x11, 128p, 170 color images, index, order no. 1841.

PROFESSIONAL CHILDREN'S PORTRAIT PHOTOGRAPHY

Lou Jacobs Jr.

Fifteen top photographers reveal their most successful techniques—from working with uncooperative kids, to lighting, to marketing your studio. $34.95 list, 8.5x11, 128p, 200 color photos, index, order no. 2001.

CHILDREN'S PORTRAIT PHOTOGRAPHY
A PHOTOJOURNALISTIC APPROACH

Kevin Newsome

Learn how to capture spirited images that reflect your young subject's unique personality and developmental stage. $34.95 list, 8.5x11, 128p, 150 color images, index, order no. 1843.

PROFESSIONAL PORTRAIT POSING
TECHNIQUES AND IMAGES FROM MASTER PHOTOGRAPHERS

Michelle Perkins

Learn how master photographers pose subjects to create unforgettable images. $34.95 list, 8.5x11, 128p, 175 color images, index, order no. 2002.

STUDIO PORTRAIT PHOTOGRAPHY OF CHILDREN AND BABIES, 3rd Ed.

Marilyn Sholin

Work with the youngest portrait clients to create cherished images. Includes techniques for working with kids at every developmental stage, from infant to preschooler. $34.95 list, 8.5x11, 128p, 140 color photos, order no. 1845.

MONTE ZUCKER'S
PORTRAIT PHOTOGRAPHY HANDBOOK

Acclaimed portrait photographer Monte Zucker takes you behind the scenes and shows you how to create a "Monte Portrait." Covers techniques for both studio and location shoots. $34.95 list, 8.5x11, 128p, 200 color photos, index, order no. 1846.

DIGITAL PHOTOGRAPHY FOR CHILDREN'S AND FAMILY PORTRAITURE, 2nd Ed.

Kathleen Hawkins

Learn how staying on top of advances in digital photography can boost your sales and improve your artistry and workflow. $34.95 list, 8.5x11, 128p, 195 color images, index, order no. 1847.

LIGHTING AND POSING TECHNIQUES FOR PHOTOGRAPHING WOMEN

Norman Phillips

Make every female client look her very best. This book features tips from top pros and diagrams that will facilitate learning. $34.95 list, 8.5x11, 128p, 200 color images, index, order no. 1848.

THE BEST OF PHOTOGRAPHIC LIGHTING 2nd Ed.

Bill Hurter

Top pros reveal the secrets behind their studio, location, and outdoor lighting strategies. Packed with tips for portraits, still lifes, and more. $34.95 list, 8.5x11, 128p, 200 color photos, index, order no. 1849.

MASTER GUIDE FOR TEAM SPORTS PHOTOGRAPHY

James Williams

Learn how adding team sports photography to your repertoire can help you meet your financial goals. Includes technical, artistic, organizational, and business strategies. $34.95 list, 8.5x11, 128p, 120 color photos, index, order no. 1850.

JEFF SMITH'S POSING TECHNIQUES FOR LOCATION PORTRAIT PHOTOGRAPHY

Use architectural and natural elements to support the pose, maximize the flow of the session, and create refined, artful poses for individual subjects and groups—indoors or out. $34.95 list, 8.5x11, 128p, 150 color photos, index, order no. 1851.

MASTER LIGHTING GUIDE
FOR WEDDING PHOTOGRAPHERS

Bill Hurter

Capture perfect lighting quickly and easily at the ceremony and reception—indoors and out. Includes tips from the pros for lighting individuals, couples, and groups. $34.95 list, 8.5x11, 128p, 200 color photos, index, order no. 1852.

POSING TECHNIQUES FOR PHOTOGRAPHING MODEL PORTFOLIOS

Billy Pegram

Learn to evaluate your model and create flattering poses for fashion photos, catalog and editorial images, and more. $34.95 list, 8.5x11, 128p, 200 color images, index, order no. 1848.

THE BEST OF PORTRAIT PHOTOGRAPHY
2nd Ed.

Bill Hurter

View outstanding images from top pros and learn how they create their masterful classic and contemporary portraits. $34.95 list, 8.5x11, 128p, 180 color photos, index, order no. 1854.

THE ART OF PREGNANCY PHOTOGRAPHY

Jennifer George

Learn the essential posing, lighting, composition, business, and marketing skills you need to create stunning pregnancy portraits your clientele can't do without! $34.95 list, 8.5x11, 128p, 150 color photos, index, order no. 1855.

BIG BUCKS SELLING YOUR PHOTOGRAPHY, 4th Ed.

Cliff Hollenbeck

Build a new business or revitalize an existing one with the comprehensive tips in this popular book. Includes twenty forms you can use for invoicing clients, collections, follow-ups, and more. $34.95 list, 8.5x11, 144p, resources, business forms, order no. 1856.

ILLUSTRATED DICTIONARY OF PHOTOGRAPHY

Barbara A. Lynch-Johnt & Michelle Perkins

Gain insight into camera and lighting equipment, accessories, technological advances, film and historic processes, famous photographers, artistic movements, and more with the concise descriptions in this illustrated book. $34.95 list, 8.5x11, 144p, 150 color images, order no. 1857.

PROFESSIONAL PORTRAIT PHOTOGRAPHY

TECHNIQUES AND IMAGES FROM MASTER PHOTOGRAPHERS

Lou Jacobs Jr.

Veteran author and photographer Lou Jacobs Jr. interviews ten top portrait pros, sharing their secrets for success. $34.95 list, 8.5x11, 128p, 150 color photos, index, order no. 2003.

EXISTING LIGHT

TECHNIQUES FOR WEDDING AND PORTRAIT PHOTOGRAPHY

Bill Hurter

Learn to work with window light, make the most of outdoor light, and use fluorescent and incandescent light to best effect. $34.95 list, 8.5x11, 128p, 150 color photos, index, order no. 1858.

THE SANDY PUC' GUIDE TO

CHILDREN'S PORTRAIT PHOTOGRAPHY

Learn how Puc' handles every client interaction and session for priceless portraits, the ultimate client experience, and maximum profits. $34.95 list, 8.5x11, 128p, 180 color images, index, order no. 1859.

MINIMALIST LIGHTING

PROFESSIONAL TECHNIQUES FOR LOCATION PHOTOGRAPHY

Kirk Tuck

Use small, computerized, battery-operated flash units and lightweight accessories to get the top-quality results you want on location! $34.95 list, 8.5x11, 128p, 175 color images and diagrams, index, order no. 1860.

THE KATHLEEN HAWKINS GUIDE TO

SALES AND MARKETING FOR PROFESSIONAL PHOTOGRAPHERS

Create a brand identity that lures clients to your studio, then wow them with outstanding customer service and powerful images that will ensure big sales. $34.95 list, 8.5x11, 128p, 175 color images, index, order no. 1862.

LIGHTING TECHNIQUES

FOR MIDDLE KEY PORTRAIT PHOTOGRAPHY

Norman Phillips

In middle key images, the average brightness of a scene is roughly equivalent to middle gray. Phillips shows you how to orchestrate every aspect of a middle key shoot for a cohesive, uncluttered, flattering result. $34.95 list, 8.5x11, 128p, 175 color images/diagrams, index, order no. 1863.

SIMPLE LIGHTING TECHNIQUES

FOR PORTRAIT PHOTOGRAPHERS

Bill Hurter

Make complicated lighting setups a thing of the past. In this book, you'll learn how to streamline your lighting for more efficient shoots and more natural-looking portraits. $34.95 list, 8.5x11, 128p, 175 color images, index, order no. 1864.